ALBERT RENGER-PATZSCH

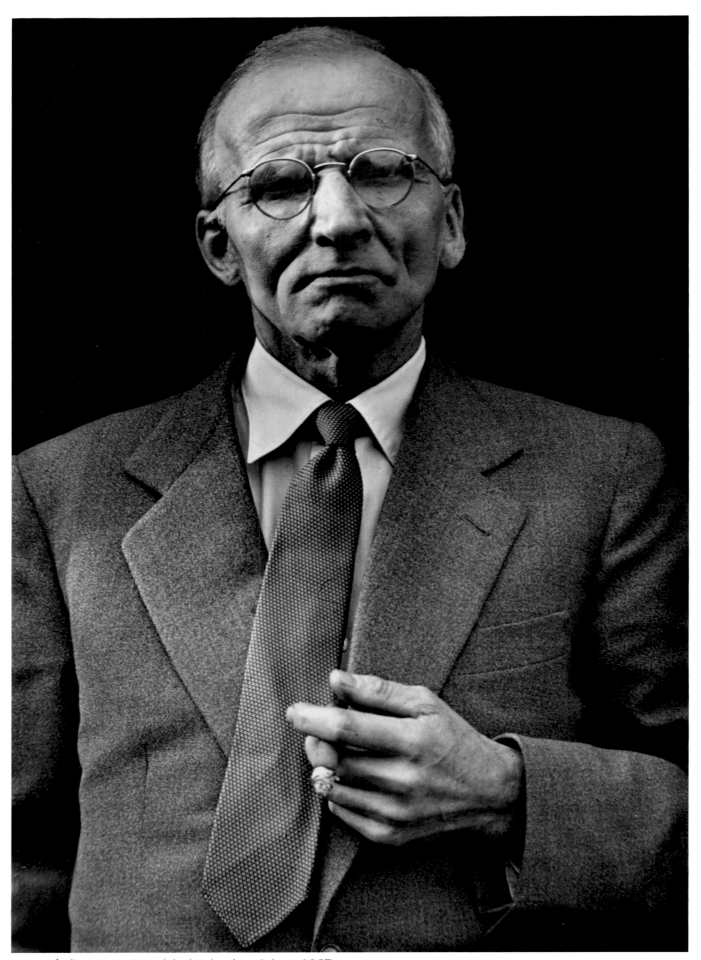

Portrait of Albert Renger-Patzsch by his daughter, Sabine, 1957

ALBERT RENGER-PATZSCH

JOY BEFORE THE OBJECT

ESSAY BY DONALD KUSPIT

PREFACE BY WESTON NAEF

APERTURE
IN ASSOCIATION WITH
THE J. PAUL GETTY MUSEUM

LENDERS

The publishers are grateful to the following public and private collections that have provided the photographs reproduced on the following pages:

The J. Paul Getty Museum, Malibu, California:
pages i i, 4, 5, 17, 19, 23, 24, 26, 27, 36, 38–45, 49–51, 53, 55–58, 60, 62, 63, 67, 71, 73, and front cover

Rudolf Kicken Galerie, Cologne, Germany:
pages 15, 20, 25, 30, 31, 37, 47, 52, 54, 61, 64, and 65

California Museum of Photography, University of California, Riverside:
pages 6, 9–12, 14, 18, 29, 33, and 35

Studio Bokelberg, Hamburg, Germany:
pages 13 and 59

The Manfred Heiting Collection, Amsterdam, Holland:
page 70

Zabriskie Gallery, New York:
page 21

Albin O. Kuhn Library and Gallery, University of Maryland, Baltimore:
page 32

Rubel Collection, Thackrey & Robertson, San Francisco, California:
page 46

PREFACE

Albert Renger-Patzsch secured his first salaried job in photography in 1922, which is a notable year in our field. The era between 1922 and 1927 was formative for Renger-Patzsch and for modernist photography in general. One of his first assignments as head of the photo studio at the Folkwang und Auriga Verlag in Hagen, Germany, was to photograph botanical specimens, often close up, which provided an opportunity for him to achieve biomorphic abstractions that relate directly to some broad concerns of experimental photographers working in Europe and America. Renger-Patzsch did not consciously associate himself with avant-garde movements of Dadaism, Constructivism, Surrealism, *Neue Sachlicheit*, or Social Realism; however, he was informed by their chief theoretical strategies.

The year Renger-Patzsch entered the field of photography as a professional, 1922, marked a turning point for several key artists in both Europe and America with whom he deserves comparison. At the outset of his career Renger-Patzsch was evidently fascinated by the process of utilizing a machine to express the poetry of purely organic forms, and by the duality of nature versus the machine. In this regard he shared concerns with other key photographers of his generation. El Lissitzky was one of the chief organizers of the International Congress of Progressive Artists, held in May in Düsseldorf (located approximately thirty-five miles from Hagen) where he discoursed on the relationships between the organic world and the mechanical one; this led to Lissitzky's own infatuation with plant forms, and his famous statement "Every form is only the frozen snapshot of a process." In Berlin at about the same time, Lucia and László Moholy-Nagy published the results of their collaborative work in the essay "Producktion-Reproducktion," in which they challenged artists to adopt novelty only when it produces "new, as yet unfamiliar relationships." The most imaginative reconciliations of the organic and the mechanical realms were the photograms Man Ray created in mid 1922 from everyday manufactured articles whose shadows were organically traced on photographic paper by placing them in direct contact with it, as well as Moholy-Nagy's photograms of later the same year. Renger-Patzsch's plant studies of 1922–1923 were counterpart manifestations to the quest by Lissitzky, Moholy-Nagy, and Man Ray to explore the highly economical ways in which nature creates its own forms by a process of maximum efficiency and minimum effort. Renger-Patzsch's work of 1922–1927 investigates through picture language the archetypes of the natural world and archetypes of the machine age.

The year 1922 in America found the words "machine" and "nature" expressed like a mantra in the work of some of the very best photographers. Paul Strand became obsessed with the highly precise forms of his Ackeley motion picture camera and the lathes used to manufacture it, which he pursued in the same year he made a series of close-up photographs of his new wife, Rebecca. Edward Weston, while on his way from home in Los Angeles to New York, stopped for a few days in Middletown, Ohio, where he studied the interaction of free form ventilation pipes and the adjacent geometrical industrial structures . While in the East in the summer of 1922 he met Alfred Stieglitz, who had just begun a series of studies of cloud formations that were pursued as the epitome of all fugitive organic manifestations.

Renger-Patzsch was totally in tune with the spirit of the experimental attitudes toward the antithesis of the mechanical and the organic, the linear and the painterly that had surfaced on two continents in 1922, and which by 1927 led him to write, "There must be an increase in the joy one takes in an object, and the photographer should be fully conscious of the splendid fidelity of reproduction made possible by his technique." Renger-Patzsch is admired for perpetually reconciling pure form with the leavening of human intelligence and human emotion.

Weston Naef, Curator of Photographs
The J. Paul Getty Museum

ALBERT RENGER-PATZSCH

A CRITICAL-BIOGRAPHICAL PROFILE
BY DONALD KUSPIT

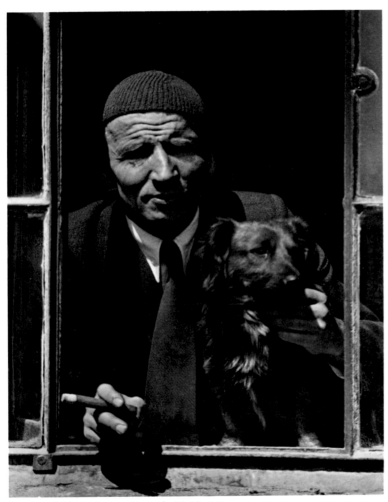

Portrait of Albert Renger-Patzsch, 1945–46

Albert Renger-Patzsch was born in Würzburg, Germany, on June 22, 1897, the youngest of three sons. His father, Robert, was a musician who owned a music and more general book business, but spent much of his time making photographs, and even published a book on the newly invented method of offset lithography. An avocation in his father became a vocation in Albert—he became an extension of his father, carrying to a professional level what his father had pursued with the passion of an amateur. Indeed, Albert not only fulfilled his father's potential, but was even more of a perfectionist.

When Albert was fourteen, his father instructed him "in the most precise way...in the technique of combined offset printing." By that time, he later wrote, he had used his father's camera to make photographs "in every format."[1] But he had not yet decided to make photography his life; indeed, he wanted to be a chemist, and in 1916 received a degree (*Abitur*) in chemistry from the Kreuz-Gymnasium in Dresden. During the First World War Renger-Patzsch performed various duties in the army, eventually becoming a scientific aide in the main office of the general staff's chemistry division. After the war he continued to study chemistry at the Dresden Technische Hochschule, to which he was admitted in 1919; but by 1921 he had realized that his "romantic ideas" were incompatible with a career as a chemist.[2] Leaving school, he became, in 1922, the director of the photography archive of the Folkwang und Auriga publishing house in Hagen. There he met a woman named Agnes von Braunschweig, whom he married in 1923. They had a daughter, Sabine, in 1924, and a son, Ernst, in 1926.

It was Ernst Fuhrmann, the owner of Folkwang und Auriga, who gave Renger-Patzsch his start as a professional photographer. Fuhrmann had had the notion of publishing a series of books, *The World of Plants*, to be illustrated with photographs, and Renger-Patzsch made the images for the first two books in the series, *Orchids* and *Crassula*, both published in 1924. In 1923, Renger-Patzsch had left Hagen for Berlin, where he worked for an agency that specialized in news photography. He subsequently became a bookkeeper for a drug business in Kronstadt, Rumania, but Fuhrmann asked him to return to Folkwang und Auriga, which he did, in various capacities, in Darmstadt and later in Bad Harzburg. In 1925 the Berlin branch of Folkwang und Auriga published the book *Das Chorgestühl von Kappenberg* (The choir stalls of Cappenberg). This was Renger-Patzsch's real professional debut, for the book carried his name, as the two books on plants did not.

Renger-Patzsch was too "self-willed and uncompromising," as Ann and Jürgen Wilde write[3]—traits increasingly evident in his photographs—to work for anyone. In 1925 he quit Folk-

wang und Auriga and set himself up in Bad Harzburg as an independent photographer. His simple, even spartan life-style never changed, and is reflected in the spareness of his photographs. That same year he had his first exhibition, in his own studio, and a second one in the Folkwang Archives in Hagen. Hanns Krenz, the business director of the Kestner Gesellschaft in Hannover, saw this second show and met Renger-Patzsch; impressed by both the work and the man, the influential Krenz arranged to show Renger-Patzsch's photographs to the friends of the Hannover Museum. Thus his career was launched. (Later, in 1929, Krenz would become an art dealer in Berlin, and would take on Renger-Patzsch.) Krenz was also responsible for bringing the photographs to the attention of Carl Georg Heise, the director of the Museum for Art and Cultural History in Lübeck. Heise was so taken by them that he invited Renger-Patzsch to that city, where, in 1927 in the Behnhaus, he gave the photographer his first one-person exhibition. Thus began a lifelong friendship.

In that same fateful year Heise persuaded Kurt Wolff to publish Renger-Patzsch's most famous book, *Die Welt ist schön* (The world is beautiful). Heise wrote the book's introduction, and exhibited Renger-Patzsch's works both in a group show of prints and photographs at Hannover's Kestner Gesellschaft and in an international photography exhibition at the Société Française de Photographie, in Paris's rue Clichy. It was this latter show that brought Renger-Patzsch his first critical acclaim. Writing under the pseudonym "Peter Panther" in the *Vossischen Zeitung*, the brilliant journalist and satirist Kurt Tucholsky dismissed all the other German photographs in the exhibition as trivial, singling out Renger-Patzsch's *Schaffende Hände* (Working hands) as "the German Pearl." Describing the photograph—an "image of the two hands of a ceramicist at the rotating wheel, the greasy clay encrusting his fingers, dripping of clay and work"—as an "altogether astonishing achievement," Tucholsky remarked that "one can almost pick up the clay, it is rendered in such strong relief" ("man kann den Ton fast abheben, so reliefartig ist es getroffen"). For Renger-Patzsch, the photograph was probably an unconscious metaphor for the way the photographer "shaped" things with his hands. (A prominent German political minister saw the hands in this image as

"the mother tongue of German hands."[4]) Tucholsky ascribed to Renger-Patzsch a "pure visual joy in the concrete thing, in material" ("reine Augenfreude am konkreten Ding, am Material"); for him, besides Renger-Patzsch's photographs the only other "living works" in the exhibition were those by American photographers.[5]

Die Welt ist schön, which Wolff published in 1928, met with similar acclaim (despite an attack from the critic Walter Benjamin). Heinrich Schwartz, the curator of the Kunsthistorisches Museum in Vienna and the author of the first monograph on the photographer David Octavius Hill—an important figure for Renger-Patzsch[6]—saw the book as a virtual revolution in photography. Writing in *Photographische Korrespondenz* in May 1929, Schwartz asserted not only that the photographs in *Die Welt ist schön* were a "revelation," but that no other contemporary painting or sculpture was as penetrating and concentrated:

The book is a signal, announcing at last the liberation of photography from the fetters of painting....Renger-Patzsch's pictures strike dumb one's attempt at the fatal comparison with painting, a comparison that was supposed to elevate the "art photography" of an earlier time to the realm of artistic creation, but that at the same time unconsciously degraded it. For a landscape photograph that looks as if it were "after a Corot," or a portrait photograph that seems to be "after a Waldmüller," must be

Schaffende Hände (Working hands), ca. 1925

a hybrid, occupying an unclear position between painting and photography without justifiably being able to claim recognition as an independent artistic creation. Renger-Patzsch's pictures are too personal in form, unique in theme [*Ausschnitte*], and "unpainterly" in motive for a superficial comparison with painting to be able to explain or clarify them. Who thinks of [Lovis] Corinth in front of Renger-Patzsch's photographs of flowers, who thinks of an animal painter in front of his delineation [*Lineament*] of an adder's head, who can find any parallel in painting to his shoe lasts, clothing material, insulator chain, guide rail, or the links of the coupling? It would be an idle undertaking. In this lies the meaning of photography: it does not want to simulate [*vortauschen*] and it does not want to veil. It does not want to be anything more or less than photography. And finally it wants to prove its independence and freedom from painting.[7]

For Schwartz, Renger-Patzsch's photographs not only accomplish this, by reason of his strong "experience of the things of the visible environment," but they communicate that experience to the spectator through an "intensity" that can be felt through the "medium of the 'dead apparatus.'"[8]

At the end of the twenties the city of Essen encouraged artists to settle there. Renger-Patzsch accepted, moving with his family to a home on the Margarethenhöhe in 1928. Establishing a studio and laboratory in the Folkwang Archives, he received commissions from industry, architects, and publishers. In the Ruhr region he found a unique "'landscape,' a mix of bourgeois homes, worker settlements, backyards, mines, metal foundries, dumps, streets, garden colonies, and agriculture in narrow plots, and began to photograph it."[9] He also developed an interest in literature, and began a correspondence with Hermann Hesse. Relationships like this one resulted in a number of portrait photographs, which he almost never exhibited. Though he admired, for example, Hugo Erfurth, in general he thought successful portrait photographers rare.

Renger-Patzsch quickly became part of the artist and craftsman community in the Ruhr, establishing friendships with the goldsmith Elisabeth Treskow, the craftsman and printer Herman Kätelhön, the painter and draftsman Hermann Schardt, and Johannes Molzahn, a founder of the Breslau Academy. In 1933, Max Burchartz, the director of the Folkwangschule, invited him to teach photography there; Renger-Patzsch was pleased, not only because of the recognition that the appointment implied, of photography as well as of himself, but because it would afford him economic security. He taught only two semesters there, however, in 1934. The Nazis had

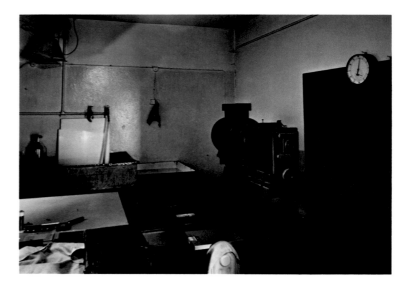

Top, Albert Renger-Patzsch's darkroom; *bottom*, the interior of his house, by Sabine Renger

begun to take over the art schools, and to dismiss anyone who didn't accept their conception of art. Renger-Patzsch would not compromise his ideas and sacrifice his academic freedom, and he resigned.

As before, he continued to earn his living from industry, architects, and publishers. He accepted commissions from the Schott glassworks in Jena, the Schloemann apparatus manufacturers, Krupp, and the Fagus works. He was also employed by the architects Fritz Schupp, Alfred Fischer, Rudolf Schwarz, and Otto Haesler, and by the publishers Langewiesche in Wasserburgen, Ferdinand Schöningh in Paderborn, and the Deutscher Kunstverlag in Oberrhein. This work excused him from service in the Second World War. Many of the artists and writers he knew were forbidden to work, or emigrated; some were even imprisoned in concentration camps. All of this seems to have shocked and depressed him.[10]

In 1944 the major part of Renger-Patzsch's archives in the Museum Folkwang was destroyed by Allied bombing. He and his family moved in with the Kätelhöns, who had left Essen for Wamel many years earlier. After the war, Renger-Patzsch decided to stay in Wamel—he felt comfortable in the Möhnesee landscape. For the remaining years of his life, nature was his major theme. This was the period when Renger-Patzsch established contact with such writers as Heinrich Böll and Ernst Jünger. Dr. Ernst Boehringer financed both his books and his travels through Europe in search of fresh landscapes; Renger-Patzsch was known to travel sixty to eighty kilometers to photograph a particular tree in early-morning light. Before photographing stones, he would read books on geology and geography. Jünger, impressed by his pictures, wrote the introduction for his last two books, *Bäume* (Trees) and *Gestein* (Stones). Shortly after the appearance of *Gestein*, and after a long illness, the photographer died, in Wamel, on September 27, 1966.

THE WORLD IS BEAUTIFUL

For Hans Namuth, an American photographer of German descent a generation younger than Renger-Patzsch, the hundred photographs in *Die Welt ist schön* brought to mind "the poetry of Renger-Patzsch's two great contemporaries Rainer Maria Rilke and Bertolt Brecht."[11] Noting that Brecht's "masterpiece, *Hauspostille*, a collection of over fifty poems, was published in 1927," just a year before Renger-Patzsch's masterpiece, Namuth writes, "One of Brecht's verses is addressed to a tree. In it, the author praises and congratulates Green, the lonely tree, for having survived a night of violent storms. Two lines read, 'You live quite alone, Green?/Yes, we are not for the masses.'" For Namuth, Renger-Patzsch's photographs are comparable to poems like this one in quality, theme, and attitude. And the photographer is as great as the poet.

The critical issue of Renger-Patzsch's photography is the camera's "consciousness" of things—that is, the use of the camera to intensify *our* consciousness of them. Namuth knew that Renger-Patzsch had wanted his book to be called *Die Dinge* (Things), but that the publisher, Kurt Wolff, thought the title *Die Welt ist schön* would be more commercial.[12] Renger-Patzsch was depressed by Wolff's decision; he felt that the new title would lead to misunderstanding of his photographs, compromising and tainting them. This was why he ironically dismissed the book as a "visiting card": the title had reduced it to banal "proof that he was able to photograph."[13]

What's in a name? It is a familiar, seemingly unanswerable question. At issue is the power of the word over the image—the word's power to focus the image in the eyes of the world,

so that it is seen in a particular way. The responses of a number of contemporary viewers of *Die Welt ist schön* suggest that Wolff's title did no harm. Thomas Mann reviewed the book positively for the *Berliner Illustrirte*, praising Renger-Patzsch's "originality" and the "boldness of his choice of objects and point of view"; for Mann, Renger-Patzsch was one of the two most important photographers in the world. (The other was Emil Otto Hoppé, in London.) And Helmut Gernsheim, a prominent connoisseur and critic of photography, later wrote that he thought that the book was a "turning point" in the history of photography, along with László Moholy-Nagy's "pioneering work" in the Bauhaus.[14]

On the other hand, the title *Die Welt ist schön* certainly predisposed Walter Benjamin to see Renger-Patzsch's book as an example of the "New Matter-of-Factness" whose "stock in trade was reportage,"[15] and Renger-Patzsch himself as a photographer on the model of "the hack writer" who "possessed no other social function than to wring from the political situation a continuous stream of novel effects for the entertainment of the public."[16] This myopic reaction would seem to justify Renger-Patzsch's fears. The photographer's real fault in Benjamin's eyes, however, was more fundamental: neither his technique nor his content was revolutionary.

At issue was a basic debate over the function of art, an issue that remains unresolved to the present day. For Benjamin, Renger-Patzsch's version of reality ignored, or suppressed, its political aspect, exhibiting a neutrality that betrayed the left-wing social cause, however unintentionally. To the Marxist Benjamin there was no such thing as political neutrality—if one was not actively in favor of the revolution, one was passively against it. Thus Renger-Patzsch was automatically a reactionary. This was apparently confirmed by the way his photographs seemed to beautify socially produced things, or else articulated the supposedly inherent beauty of natural things; to Benjamin, this meant that he didn't just have a naive view of reality, he consciously falsified it. His photography conformed to an old aesthetic of transfiguring appearances, rather than to the new artistic ideal of using art to influence social opinion, and even as direct social action. To keep the medium of photography in this retarded state of ideological innocence and indifference was to betray its promise, indeed, for Benjamin, its destiny: its use value as a means of disclosing class character and the reality of social power.

Namuth describes how Renger-Patzsch emphasizes the details of things until they seem to "vibrate with life, some to a disturbing degree." It is a quality that strikingly distinguishes these photographs from what Benjamin called "reportage." But so blind is Benjamin to this quality, so savagely did he attack the work, that one wonders whether he actually looked at it more than passingly. He preferred an artist such as John

(continued on page 66)

There is an urgent need to examine old opinions and look at things
from a new viewpoint. There must be an increase in the joy one takes
in an object, and the photographer should become fully conscious of the
splendid fidelity of reproduction made possible by his technique. Nature,
after all, is not so poor that she requires constant improvement.
—Albert Renger-Patzsch
"Joy Before the Object," 1928

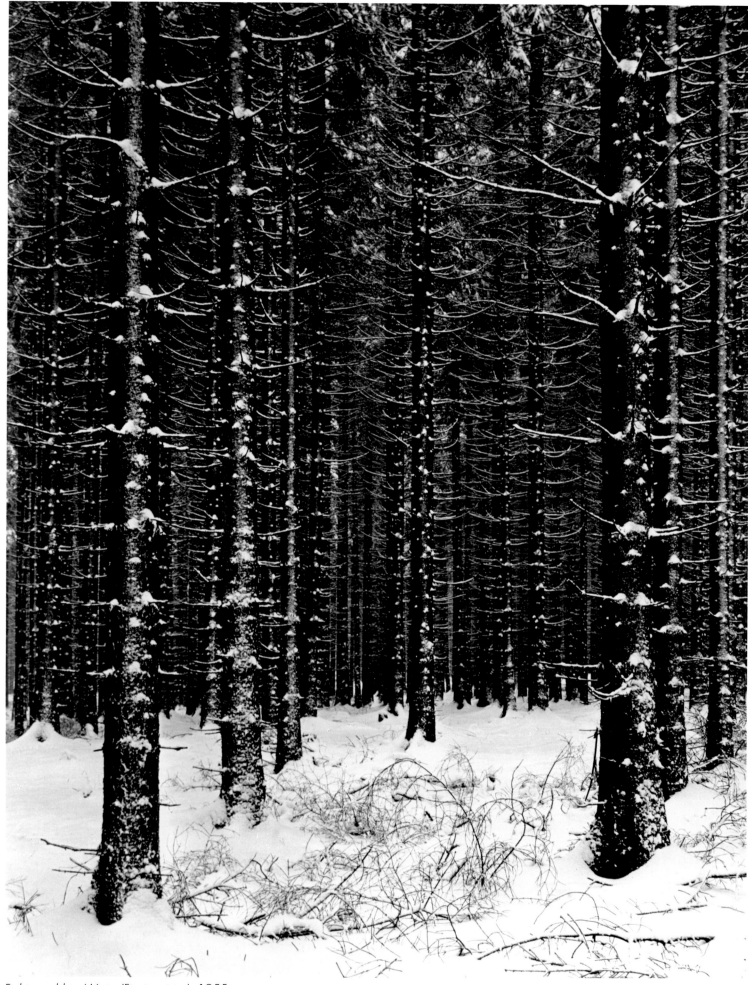

Fichtenwald im Winter (Firs in winter), 1955

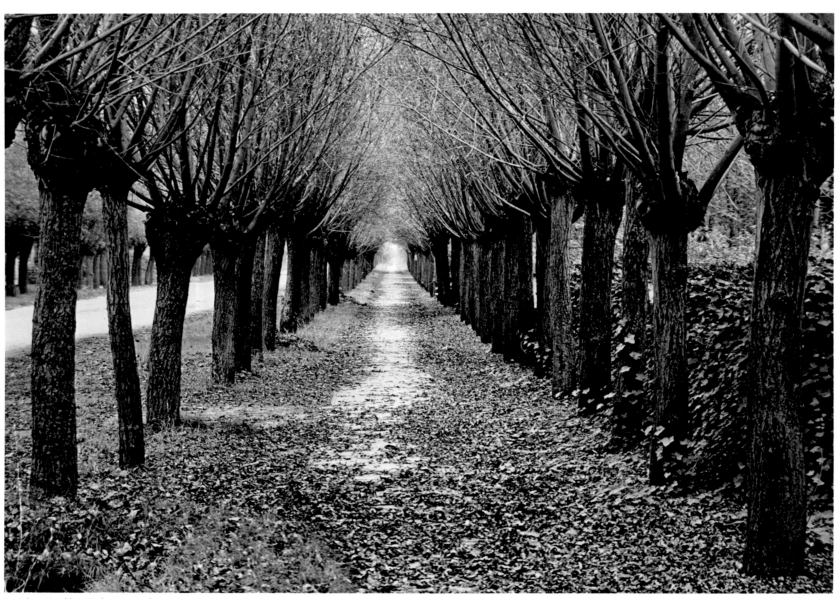

Road in Knokke, Belgium, n.d.

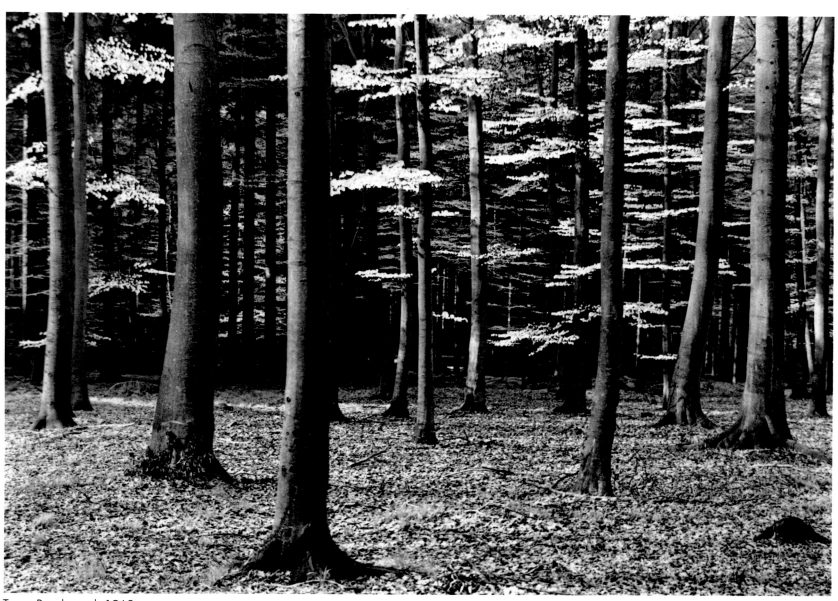

Trees, Beechwood, 1962

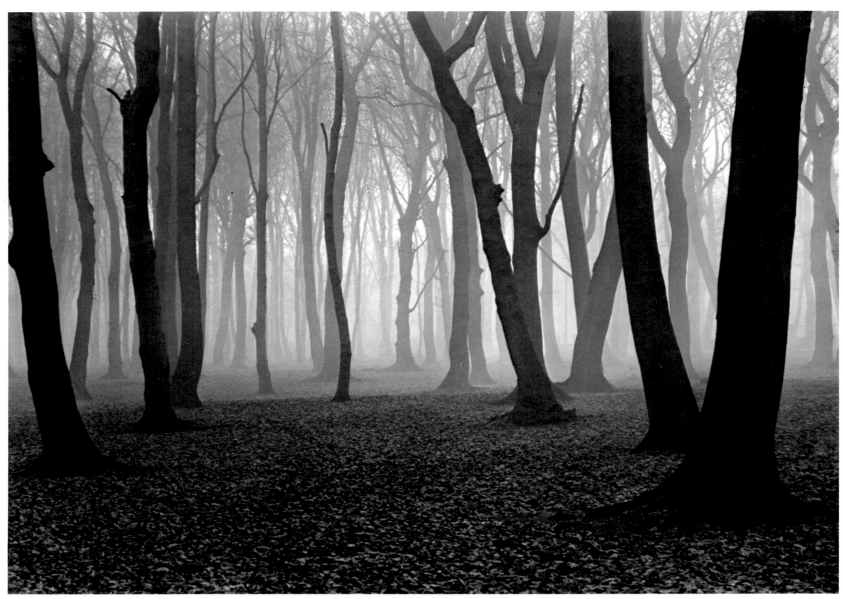

Woods in November, 1934

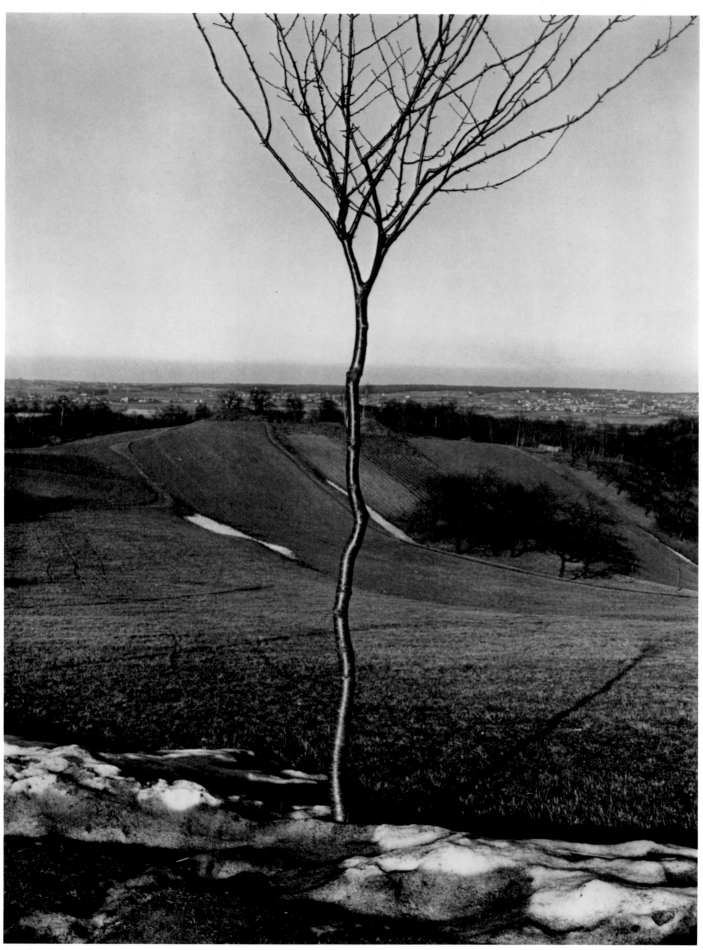

Das Bäumchen (The little tree), ca. 1929

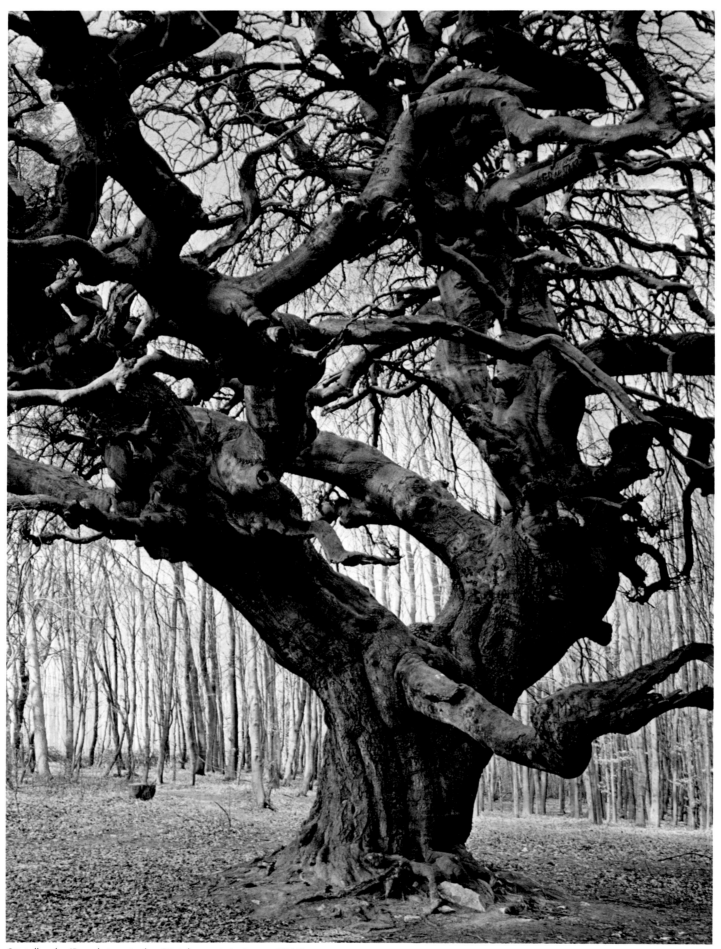

Süntelbuche (Beech tree in the Süntel mountains), ca. 1962

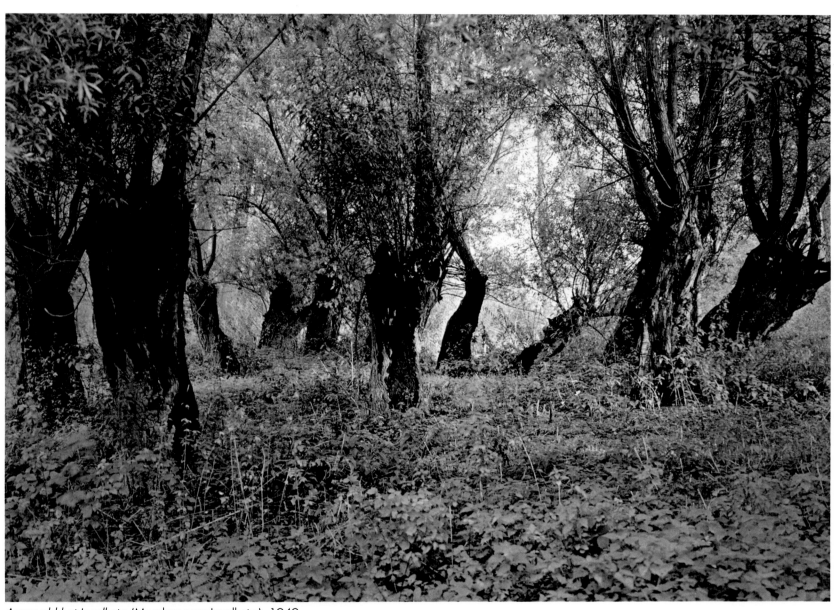

Auenwald bei Ingelheim (Meadow near Ingelheim), 1949

The fact that a fragment can symbolize the whole, and that enjoyment and empathy are mutually exalting when the imagination is forced to collaborate in the experience—this is an area in which landscape photography offers a multitude of possiblities.

—Carl Georg Heise, from
The World is Beautiful, 1929

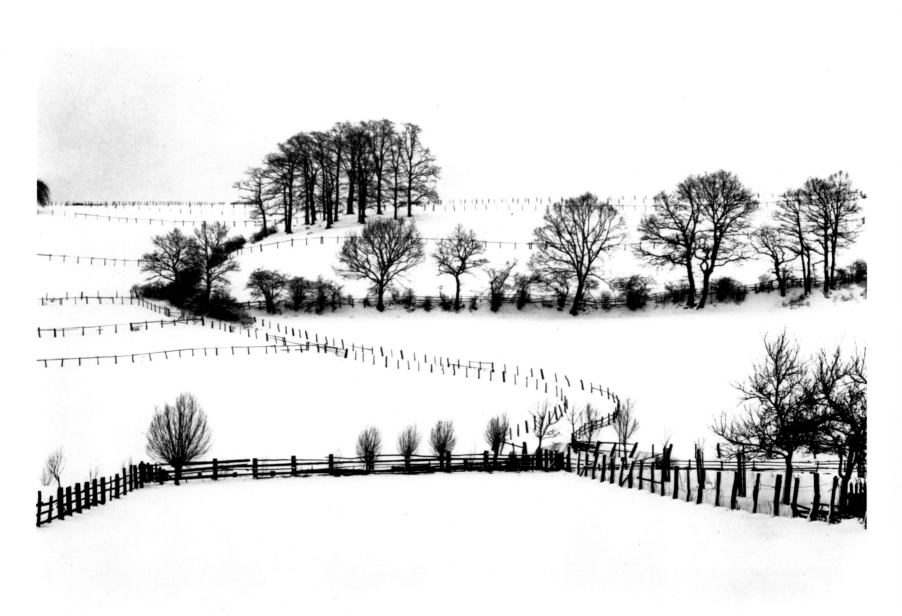

Eichenkamp in Wamel (Oak grove in Wamel), ca. 1952

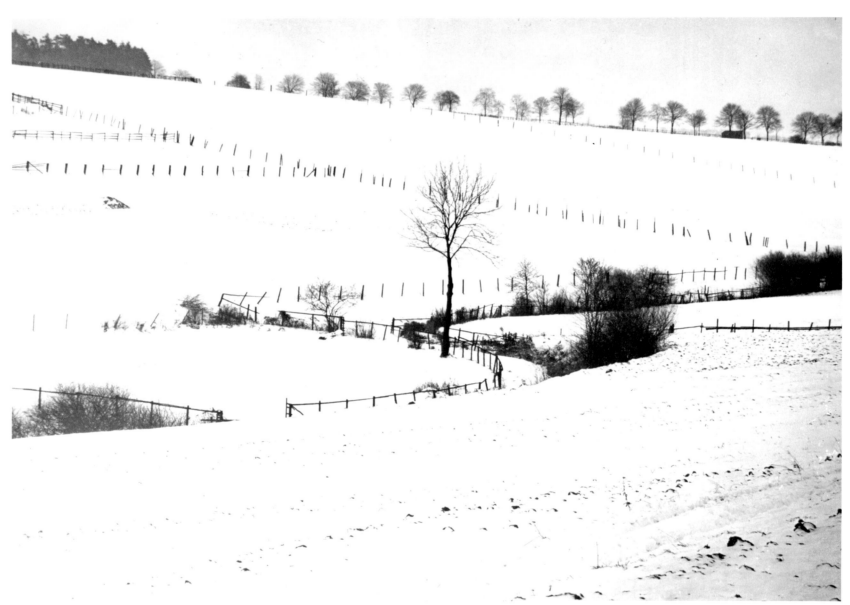

Winter Landscape in Wamel, 1958

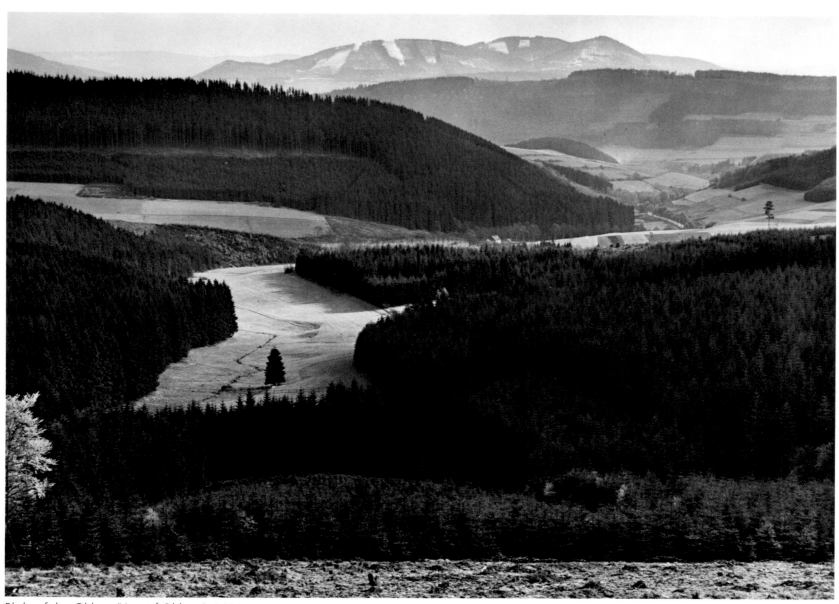

Blick auf den Olsberg (View of Olsberg), 1957

Ausschnitt Buchenbäume am Teich (A view of beech trees by a pond), n.d.

Bergahorne auf dem Grossen Ahornboden im Karwendel
(Sycamores on the large sycamore grove in the Karwendel mountains), 1947

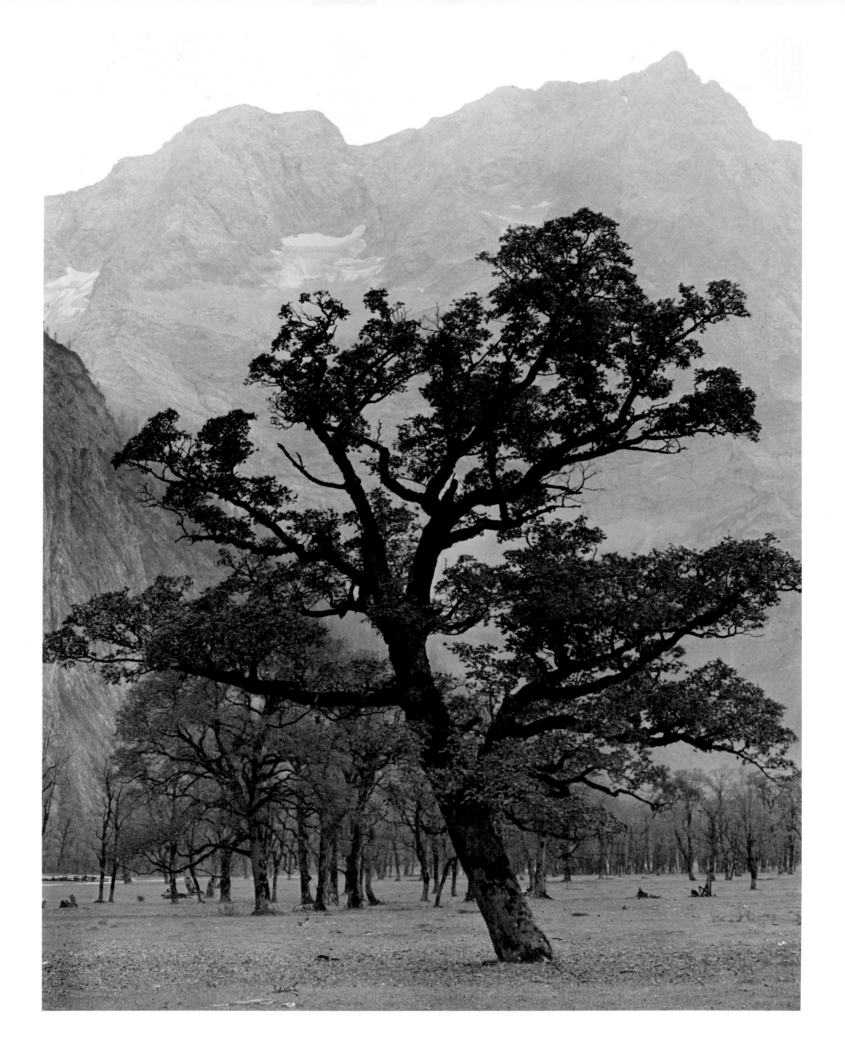

The absolutely correct rendering of form, the subtlety of tonal gradation from the brightest highlight to the darkest shadow, impart to a technically expert photograph the magic of experience. Let us therefore leave art to the artists, and let us try to use the medium of photography to create photographs that can endure because of their *photographic* qualities....
—Albert Renger-Patzsch, 1927

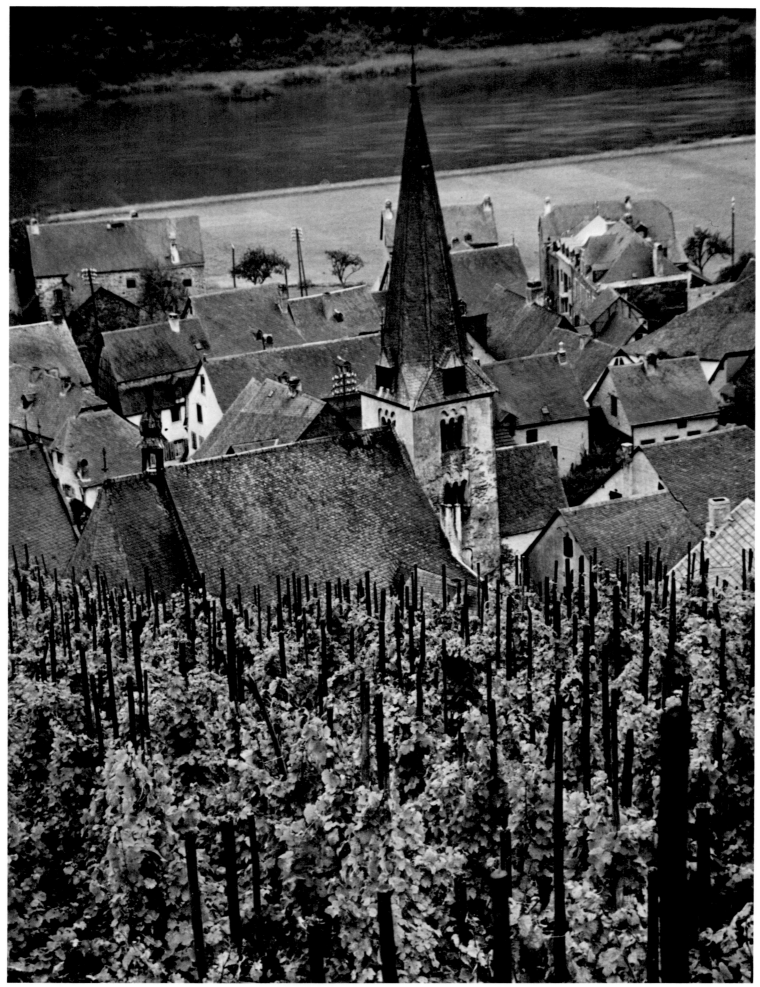

Moselstädtchen (Ediger) (Small Town on the Moselle, Ediger), ca. 1950

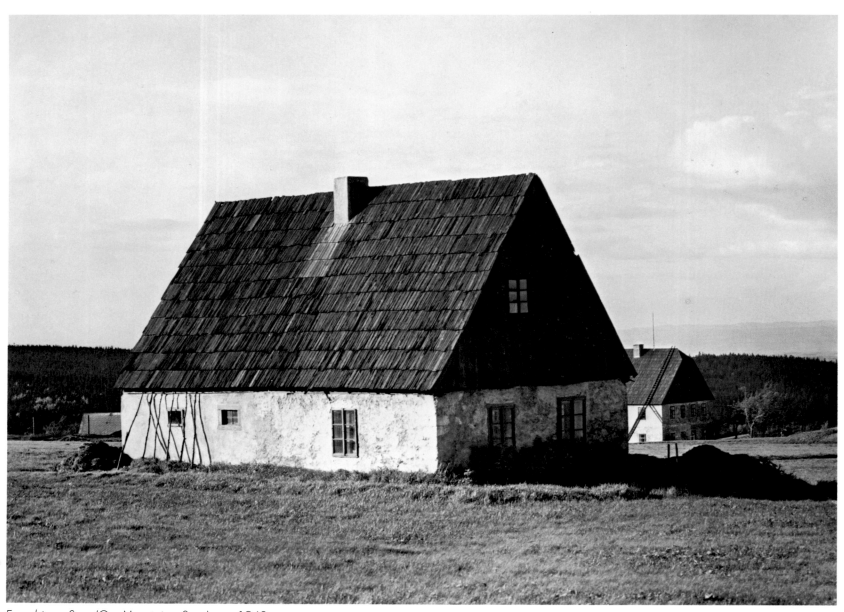

Erzgebirge, Sosa (Ore Mountains, Sosa), ca. 1940

Erzgebirge, Sosa (Ore Mountains, Sosa), ca. 1930

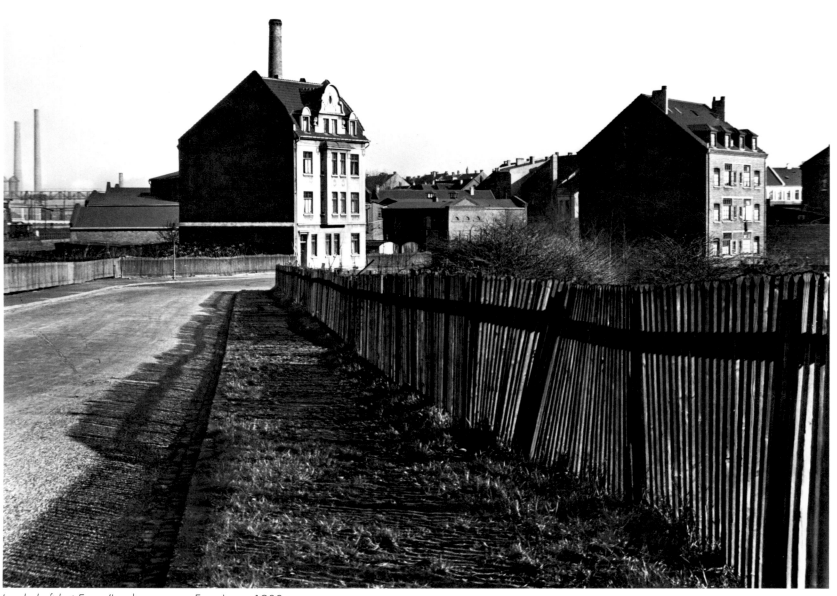

Landschaft bei Essen (Landscape near Essen), ca. 1930

Erstes Haus in Essen wenn man vom westen heim kommt
(First house in Essen when one approaches home from the west), ca. 1928

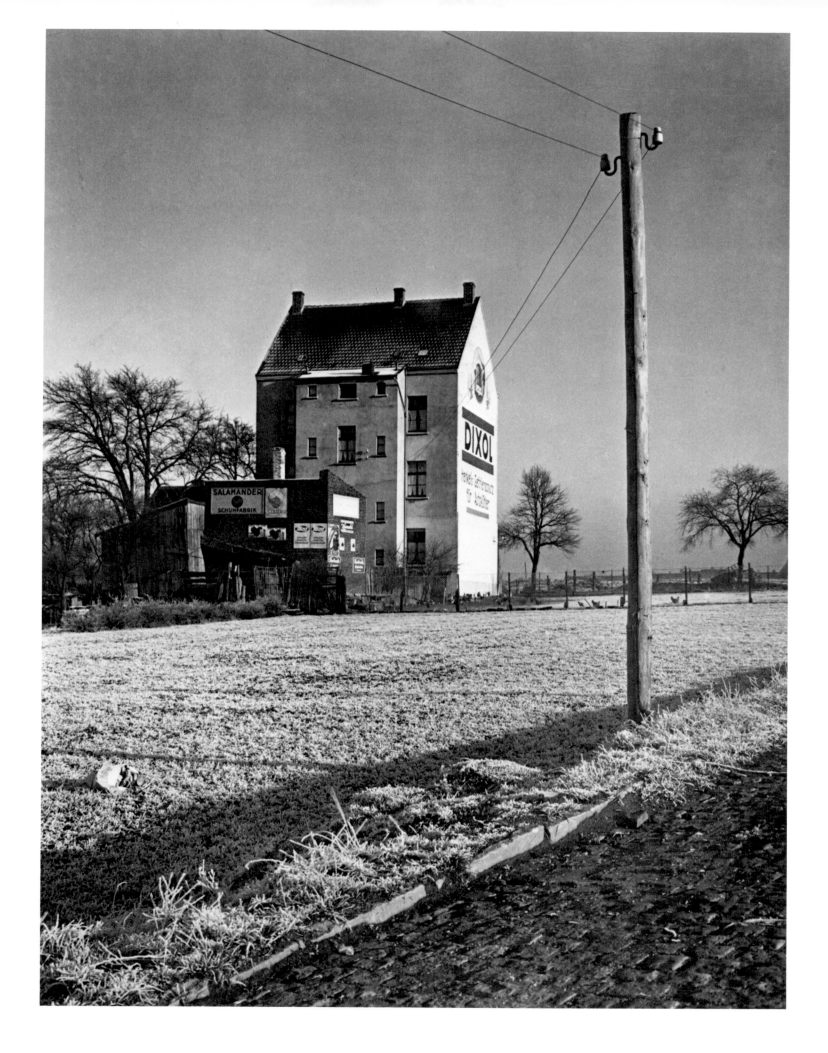

I lean toward Steichen's view that the [Otto] Steinert school of photography is headed toward a dead end. Man Ray and Moholy, and to an extent Florence Henri, did it all much better back in 1925. While people like Cartier-Bresson and Bill Brandt, in my opinion, represent a new era in photography. Using the extraodinary new techniques available today, they are setting a course that was suggested in the work of Atget, occasionally also in Stieglitz, but which far surpasses both of them. Sometimes I have the feeling that this type of picture-taking is the first legitimate assignment for photographers, that is, an assignment that could only be carried out by photography.

—Albert Renger-Patzsch, 1956

Hohenburgstraße am Bahndamm des Hauptbahnhofs in Essen
(Street in Essen at the train station), 1928

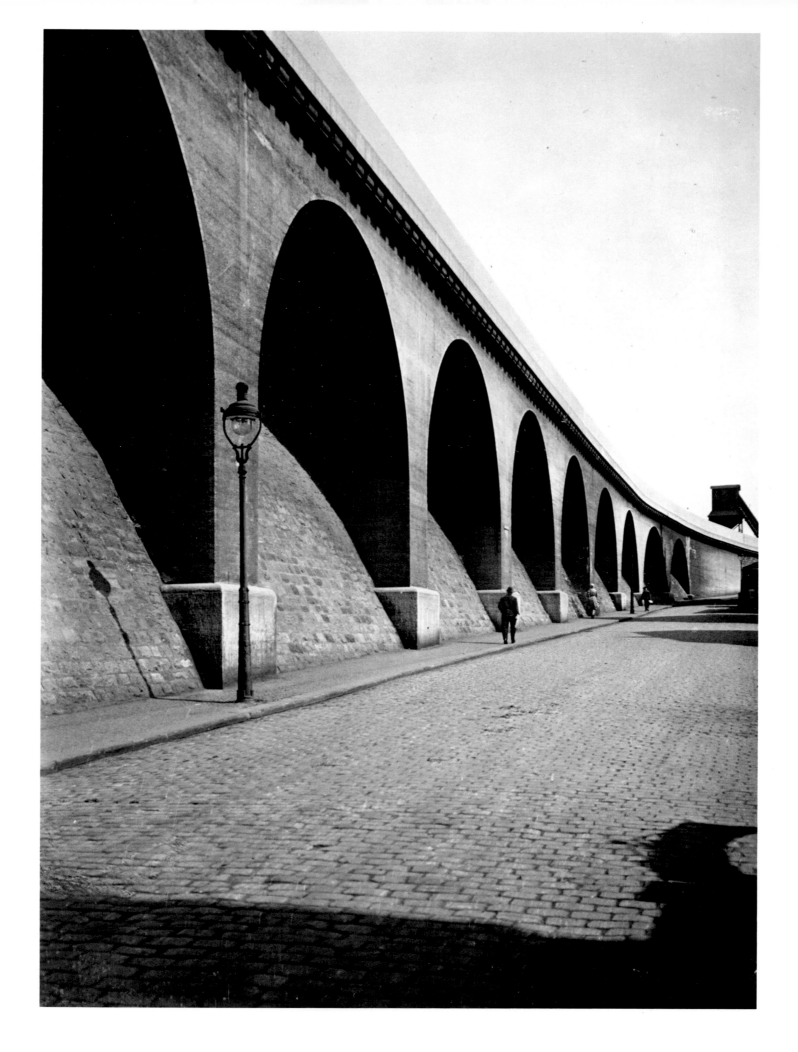

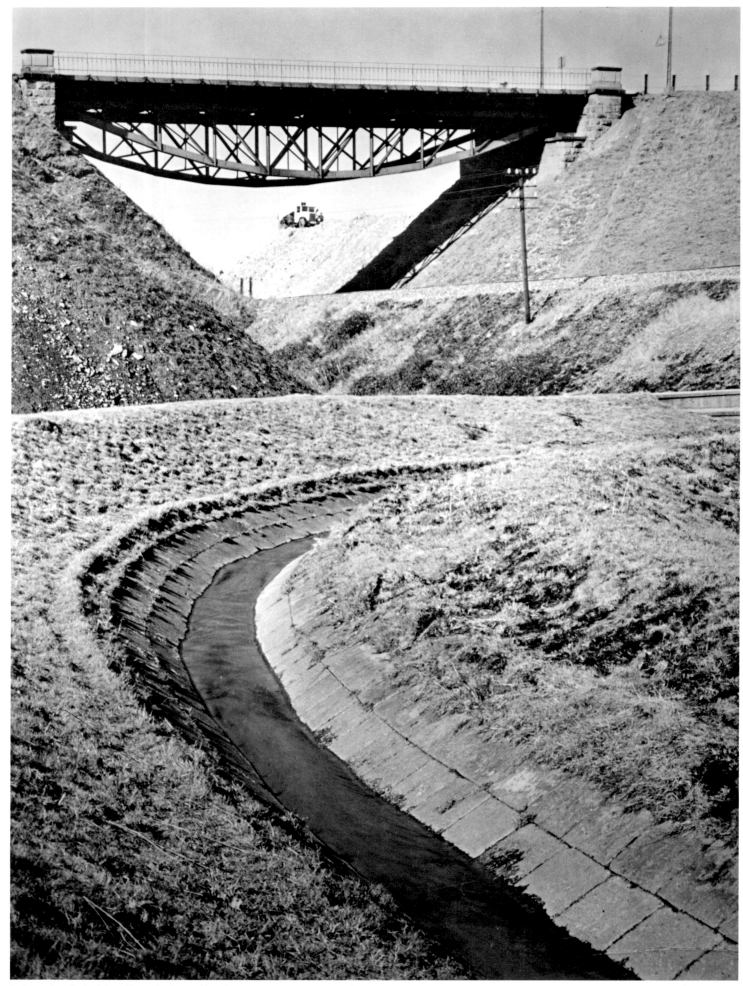

Industrielandschaft bei Essen (Industrial landscape near Essen), 1930

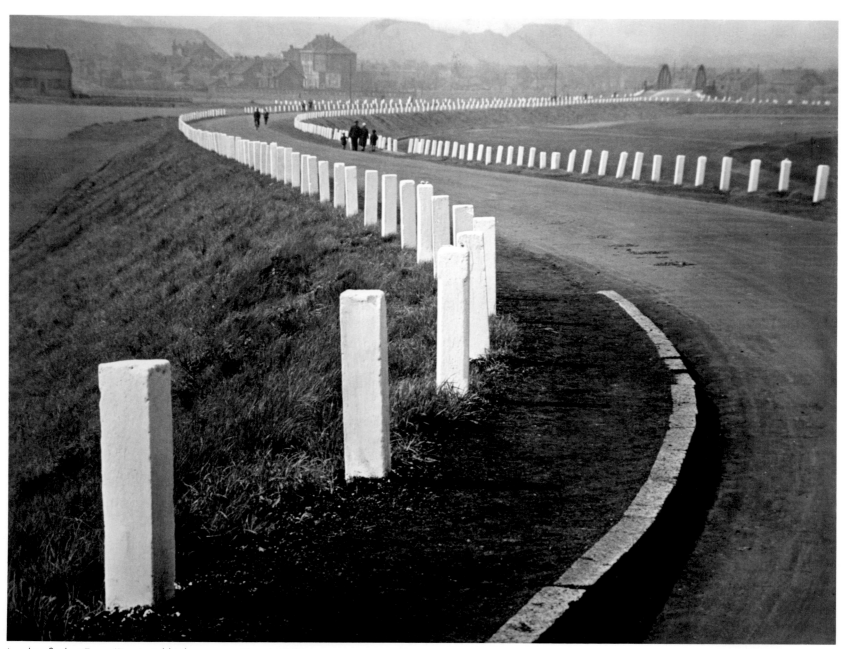

Landstraße bei Essen (Provincial highway near Essen), 1929

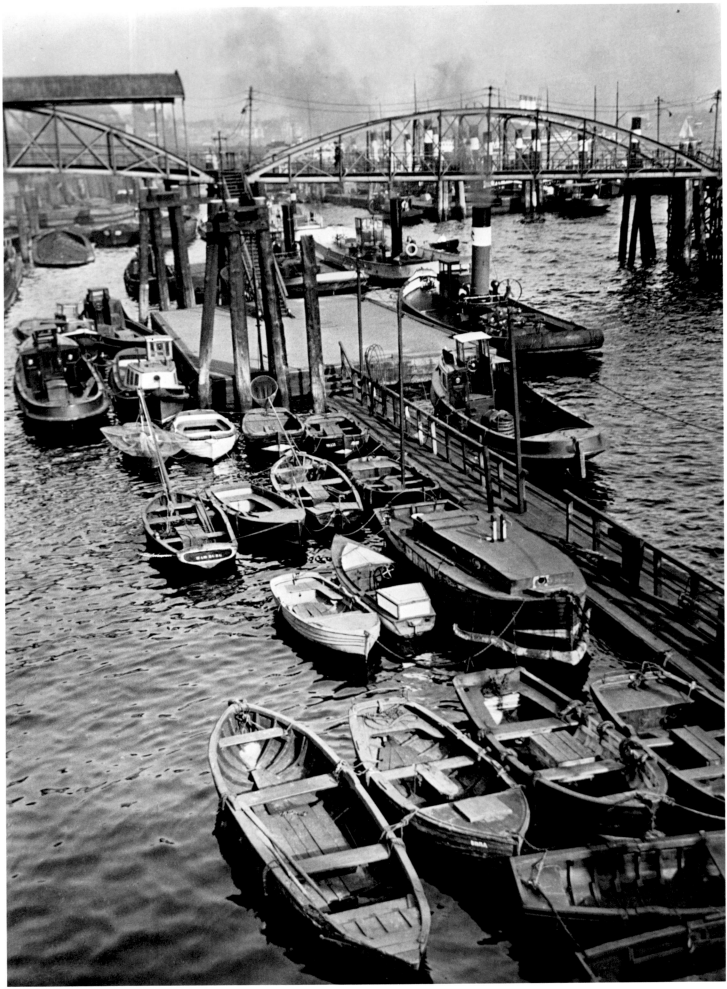

Hilfsfahrzeuge im Hafen (Auxiliary craft in harbor), ca. 1930

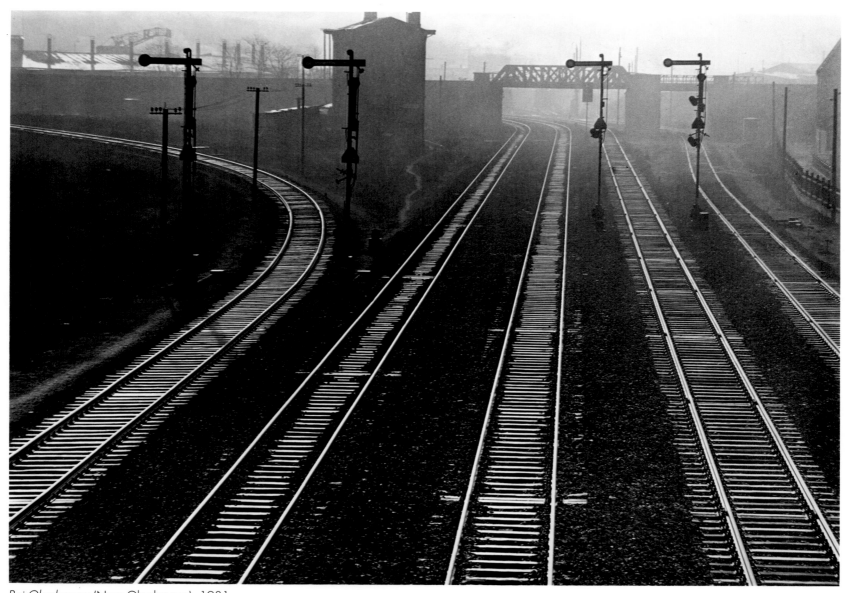

Bei Oberhausen (Near Oberhausen), 1931

If he is a great master of the technique, then in a moment [the photographer] can conjure up things which will call for days of effort from the artist, or may even be totally inaccessible to him, in realms which are the natural home of photography. Whether it be as the sovereign mistress of the fleeting moment, or in the analysis of individual phases of rapid movement; whether to create a permanent record of the transient beauty of flowers, or to reproduce the dynamism of modern technology.

—Albert Renger-Patzsch, 1929

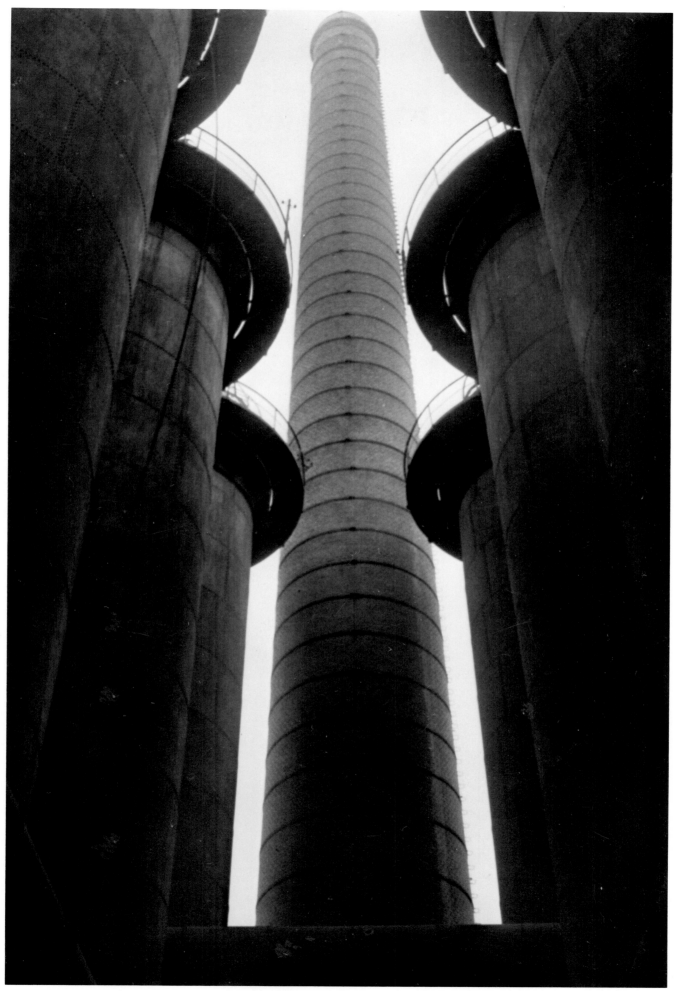

Kauper von unten gesehen. Hochofenwerk, Herrenwyk (Herrenwyk blast furnace, as seen from below), 1928

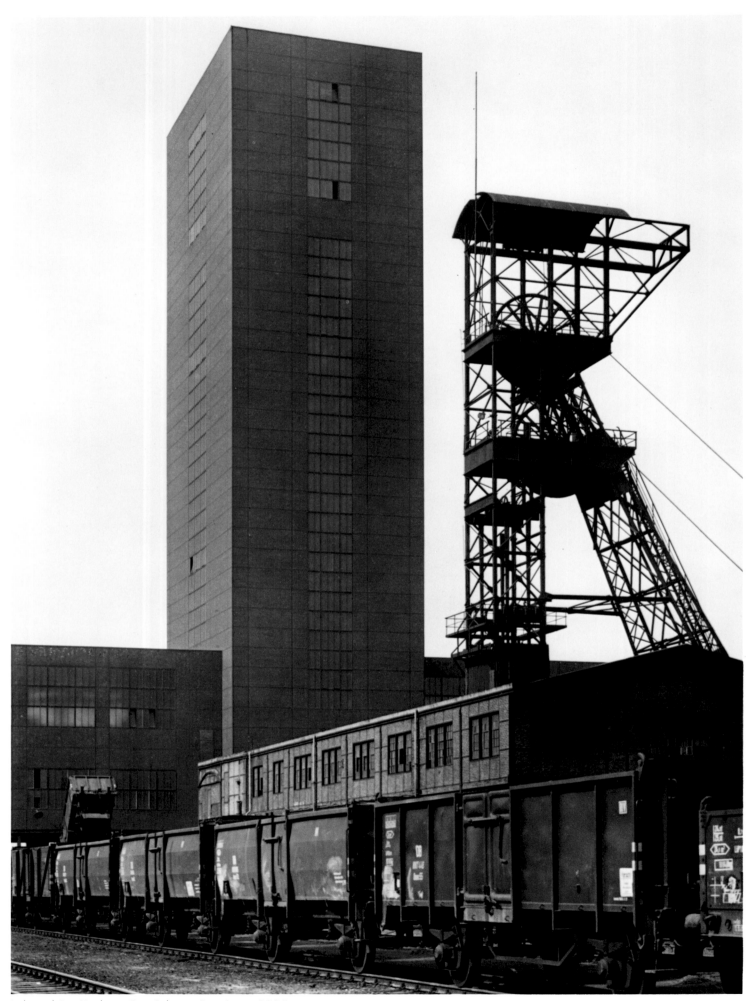

Industrial Site (Architect Fritz Schupp, Essen), ca. 1955

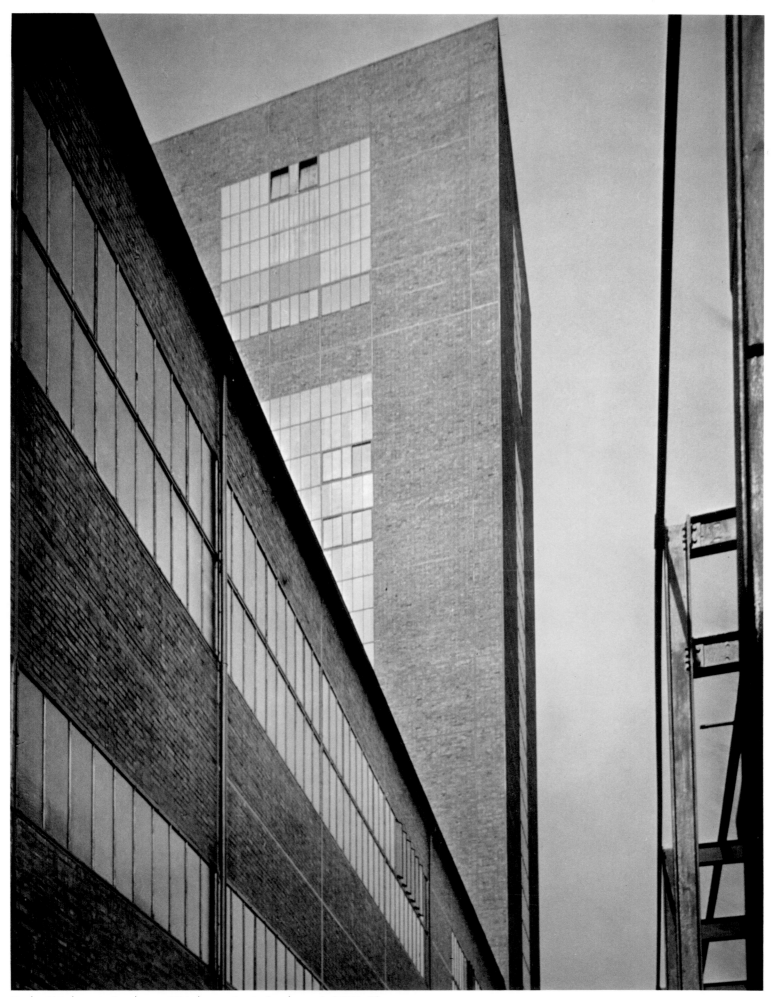

Zeche Grimberg in Bergkamen (Grimberg mine in Bergkamen), 1951–52

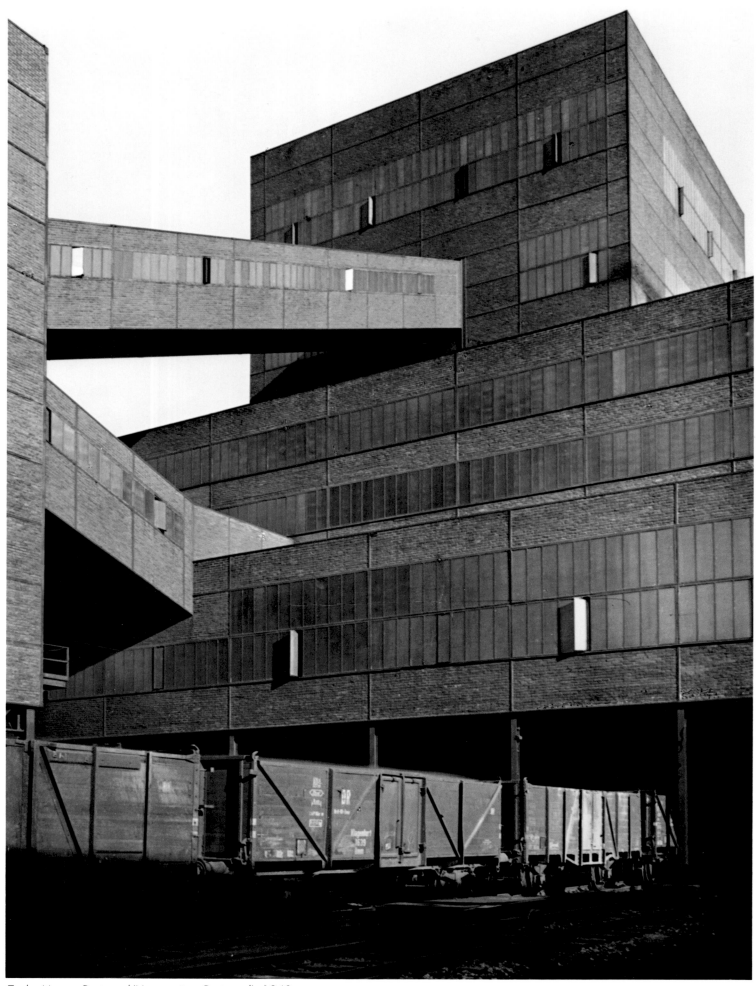

Zeche Hansa, Dortmund (Hansa mine, Dortmund), 1948

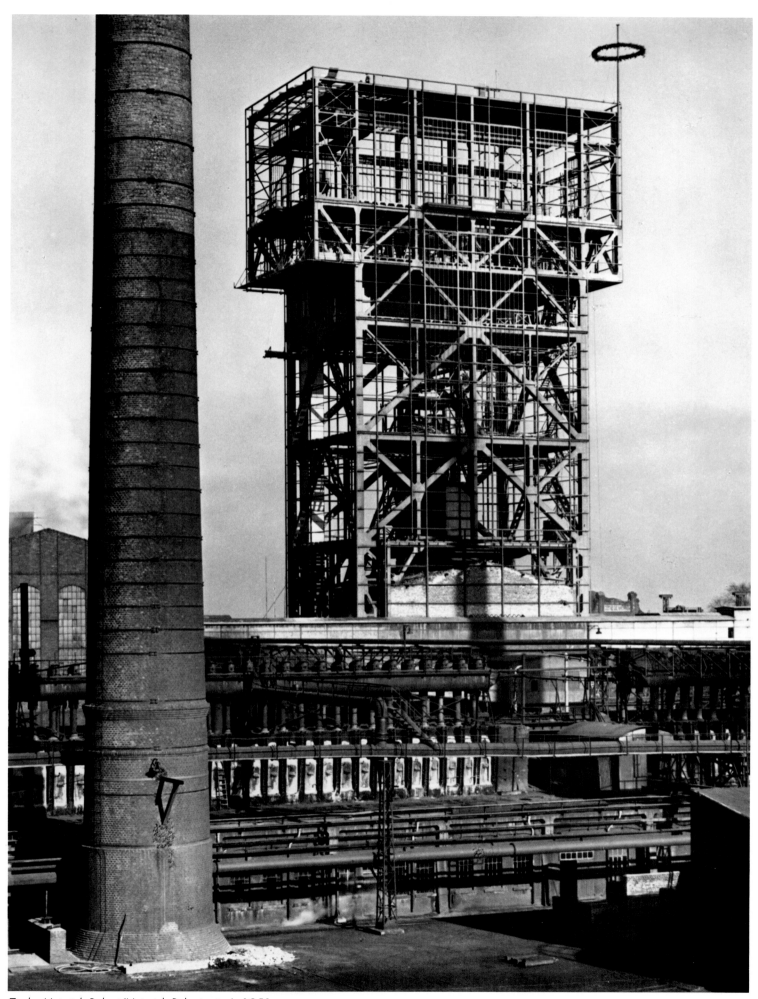

Zeche Heinrich Robert (Heinrich Robert mine), 1951

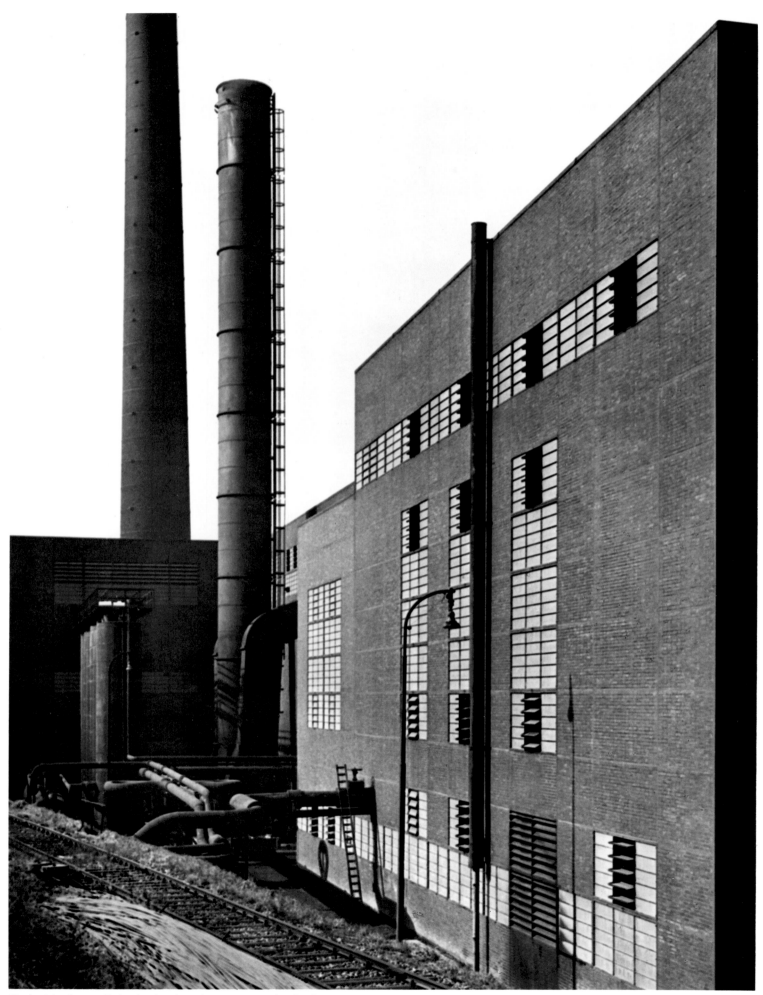

Zeche Nordstern, Gelsenkirchen (Northstar mine, Gelsenkirchen), 1928

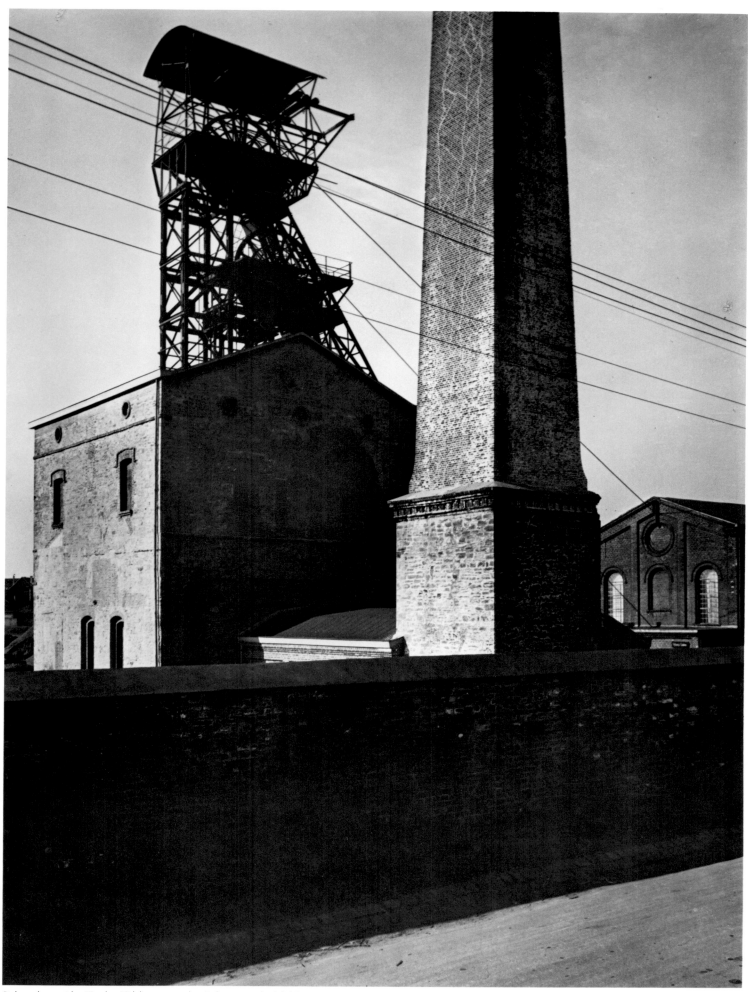

Ruhrgebiet, Alte Zeche (Old mine in the Ruhr region), 1928

I'd like to briefly state the accomplishment
that we expect from a photographer. He must
make the person being photographed forget
that he has eaten from the tree of knowledge.
—Albert Renger-Patzsch, 1956

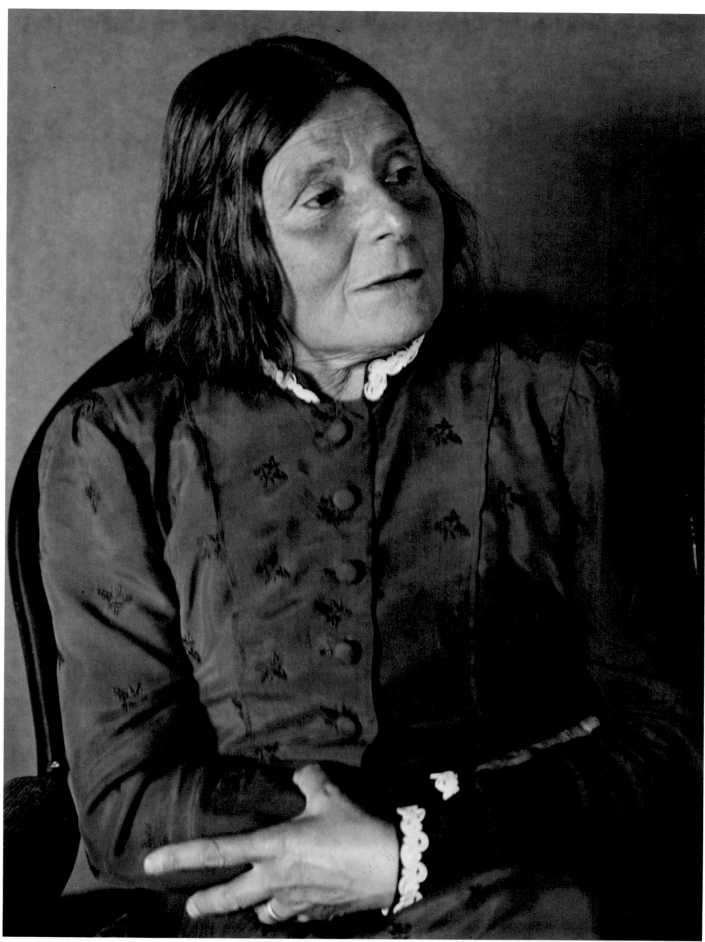

Frau Caecilie Viegener, ca. 1950

Male portrait: Bass Singer, ca. 1938

44

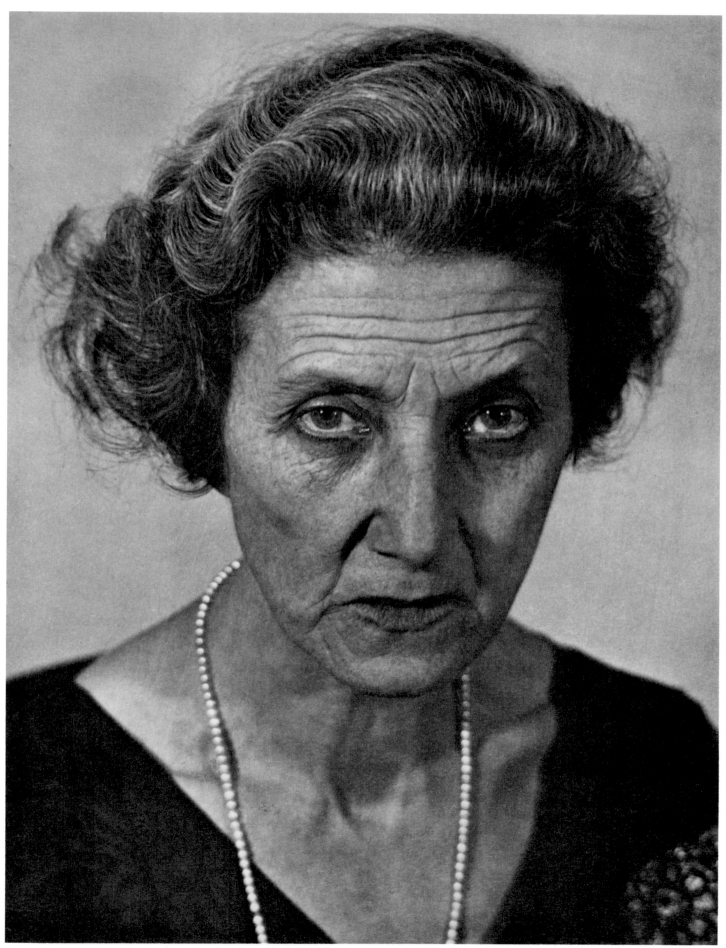

Frauenporträt (Portrait of a woman), ca. 1940

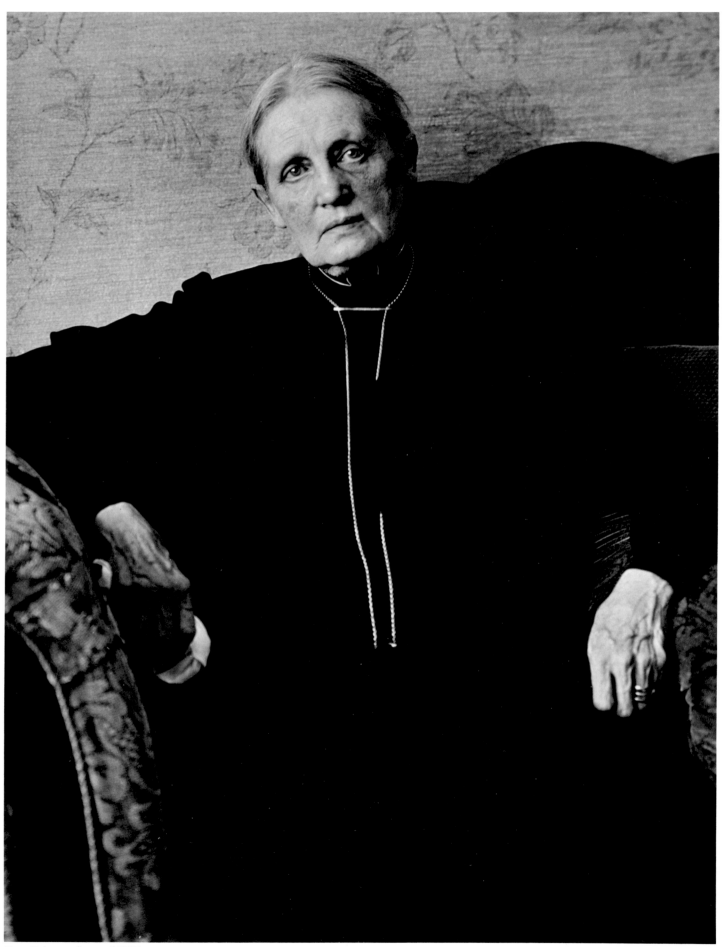

Frau Schöningh, ca. 1927

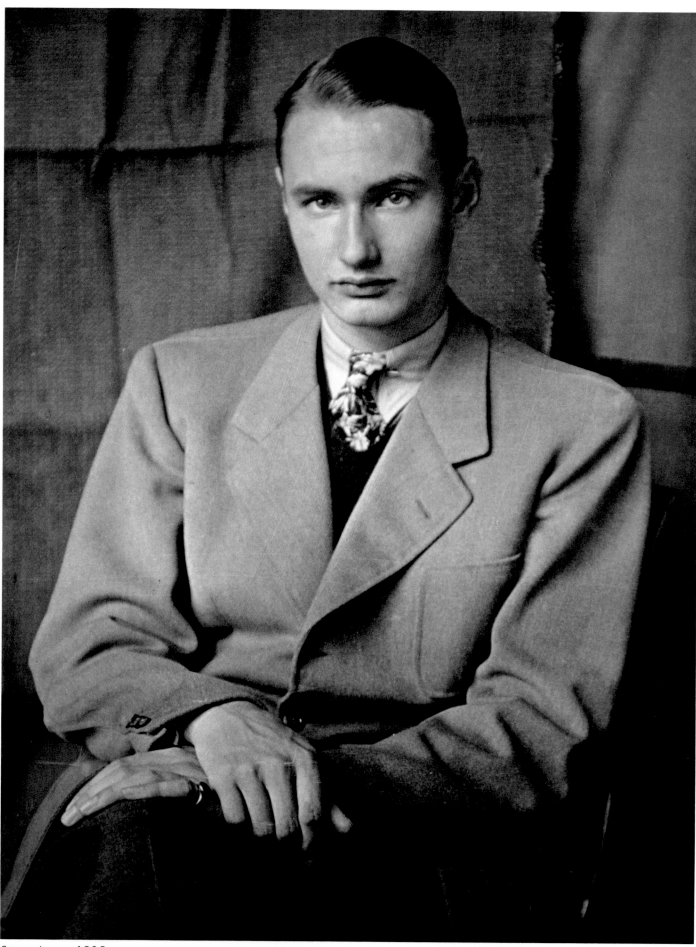

Stinnes Jr., ca. 1935

We still don't sufficiently appreciate the opportunity to capture the magic of material things. The structure of wood, stone, and metal can be shown with a perfection beyond the means of painting....

To do justice to modern technology's rigid linear structure, to the lofty gridwork of cranes and bridges, to the dynamism of machines operating at one thousand horsepower—only photography is capable of that.

—Albert Renger-Patzsch, 1927

Ilsender Hütte: Eine Reihe von Stromerzeugern
(Ilsender foundry: a row of generators), 1925–26

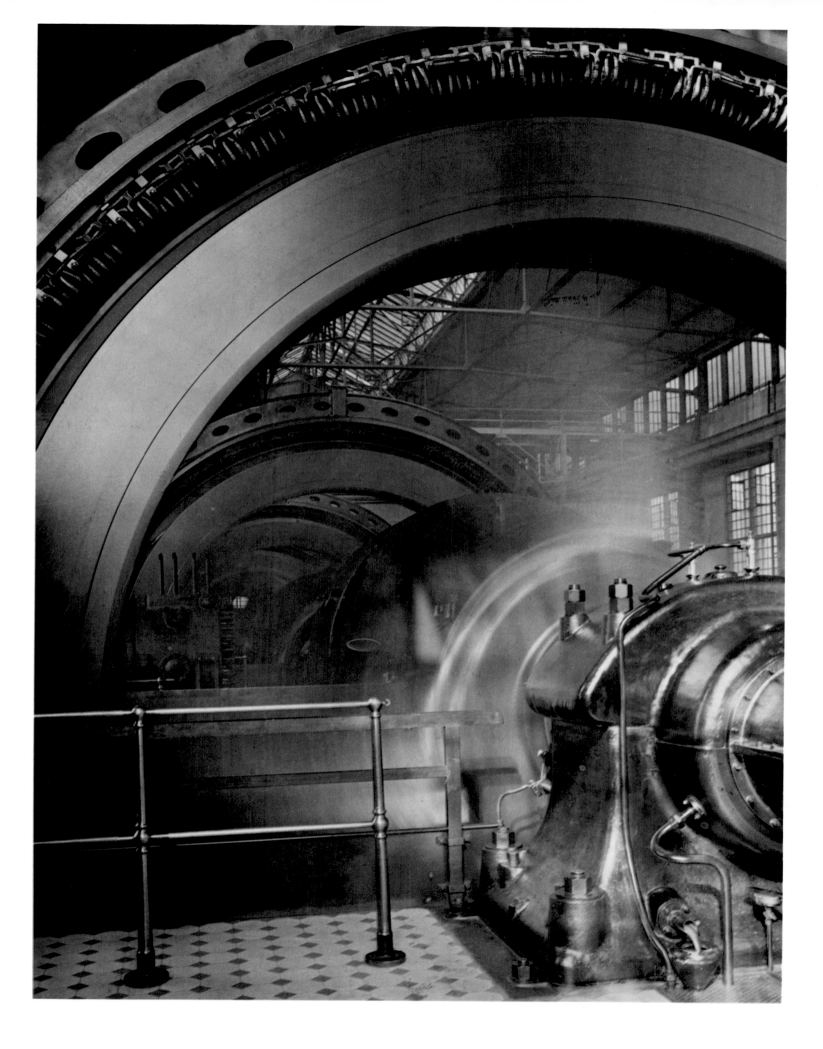

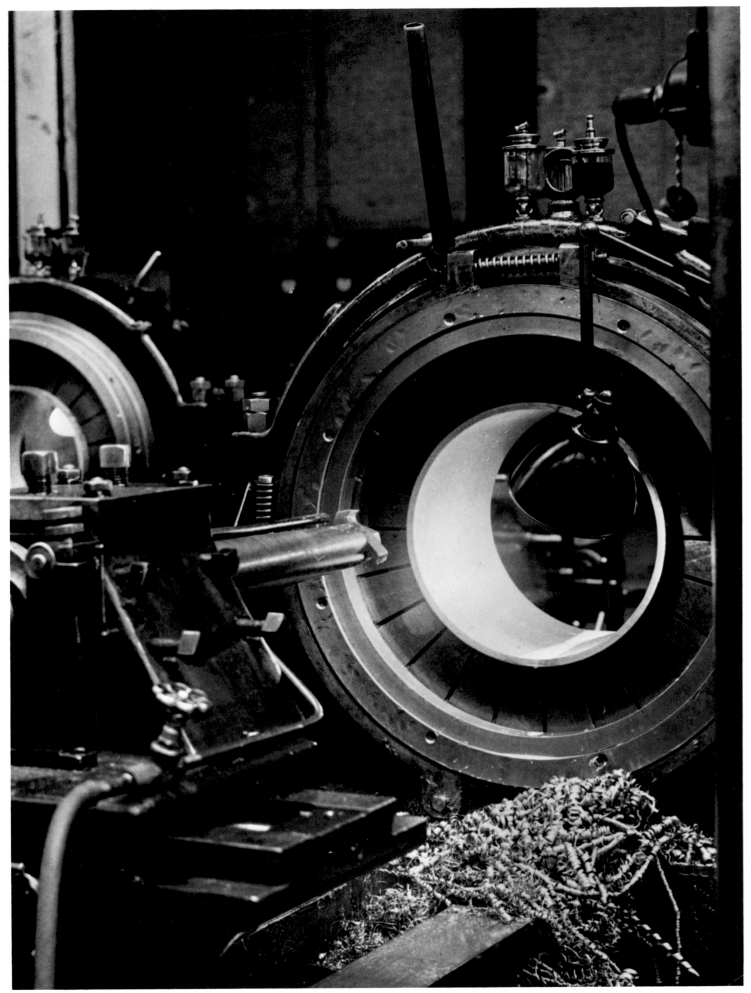

Untitled (Machine Composition), ca. 1930

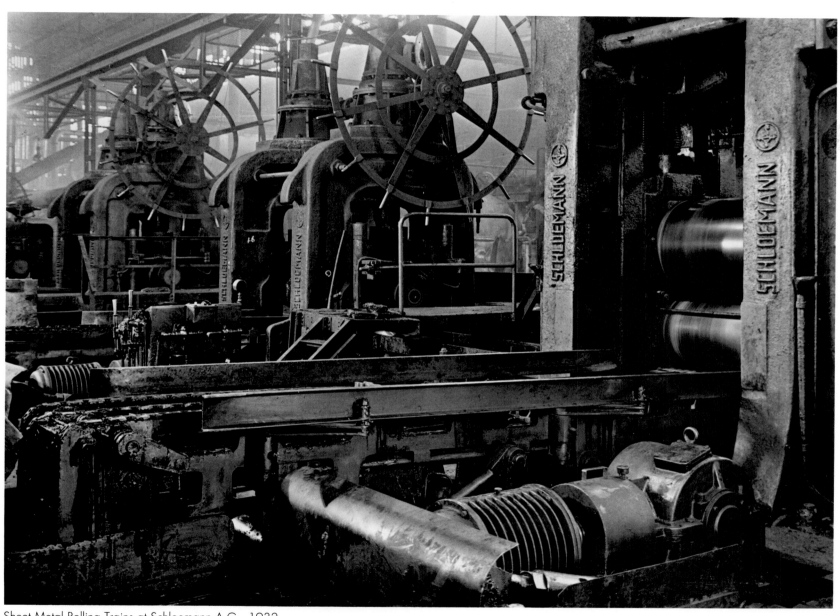

Sheet Metal Rolling Trains at Schloemann A.G., 1932

Machinendetail (Machine detail), ca. 1930

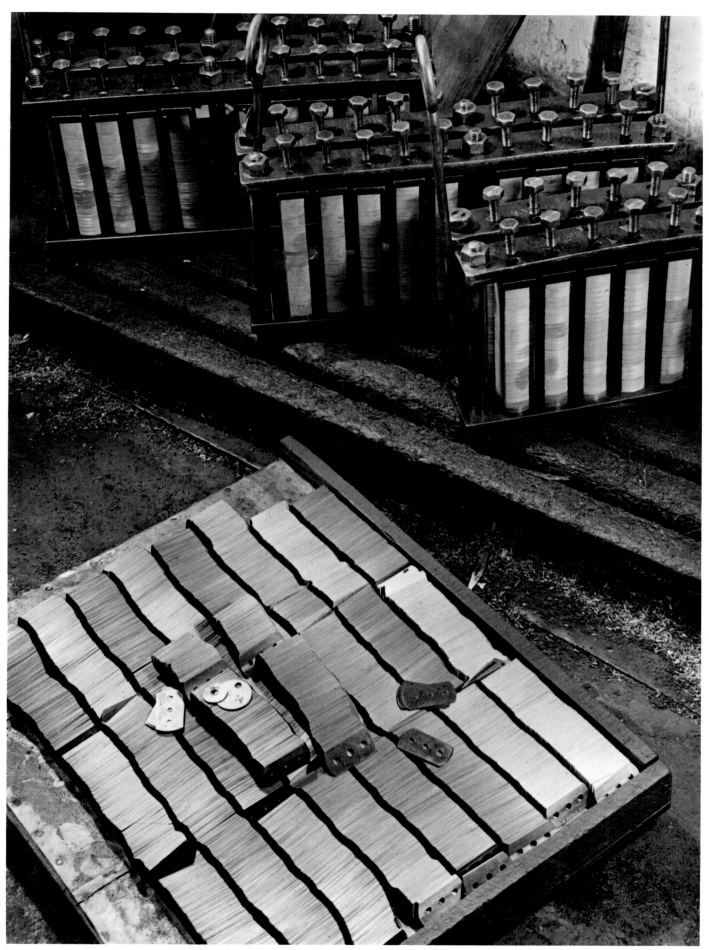

100,000 Rasierklingen (100,000 razor blades), ca. 1930

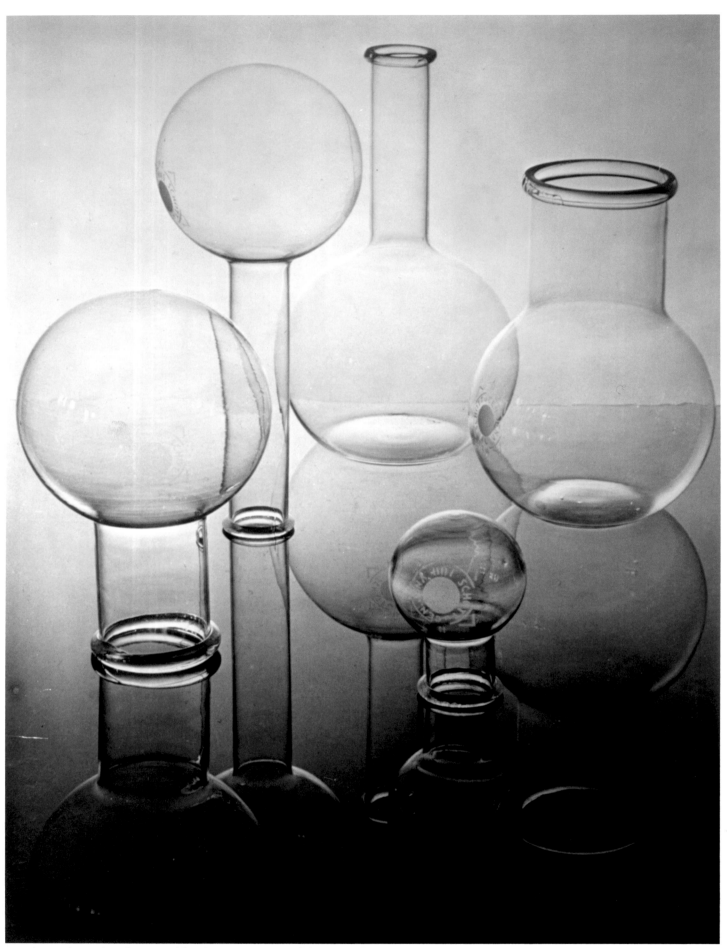

Hitzebeständige Laborgläser (Kochflaschen) (Heat-resistant laboratory glasses), 1936

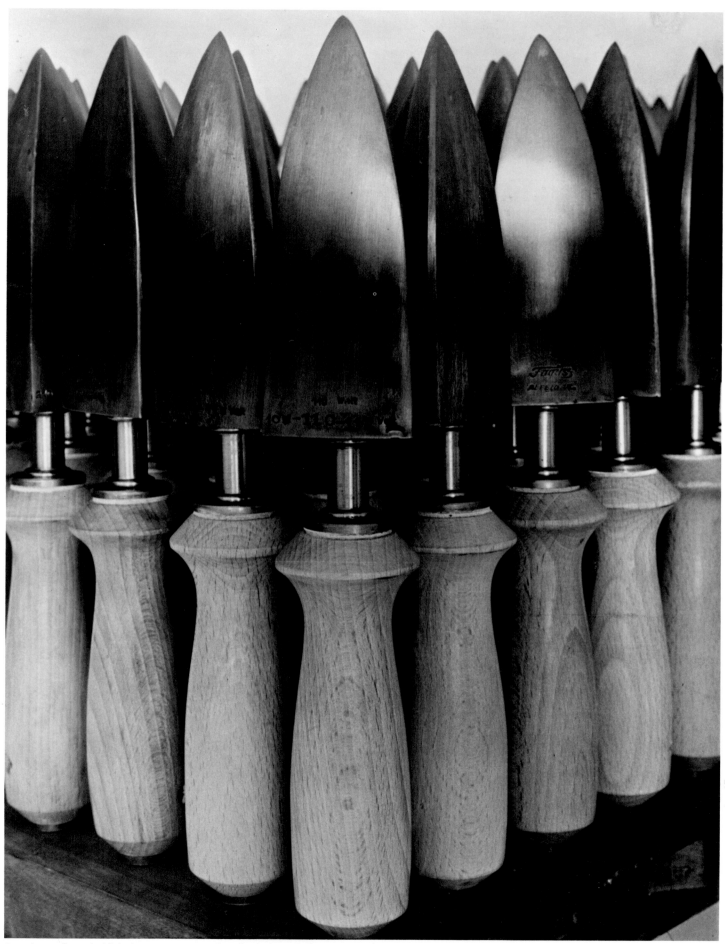

Bügeleisen für Schuhfabrikation, Faguswerk, Alfred (Flatirons for shoe manufacture), ca. 1926

For many years a certain higher ambition defined my existence, which had in general only to do with my profession. This later changed fundamentally. I now can only view my profession as part of the larger story of my life. To be fair, though, I must admit that this ambition gave rise to worthy achievements...which in turn had an effect on my overall outlook. I will briefly outline the consequences: an insurmountable aversion to any ideology, which in my experience always degenerates into political or intellectual dictatorship, and a predilection for Knowledge as the force of order and reason that teaches us the relative importance of Things.

—Albert Renger-Patzsch, ca. 1960

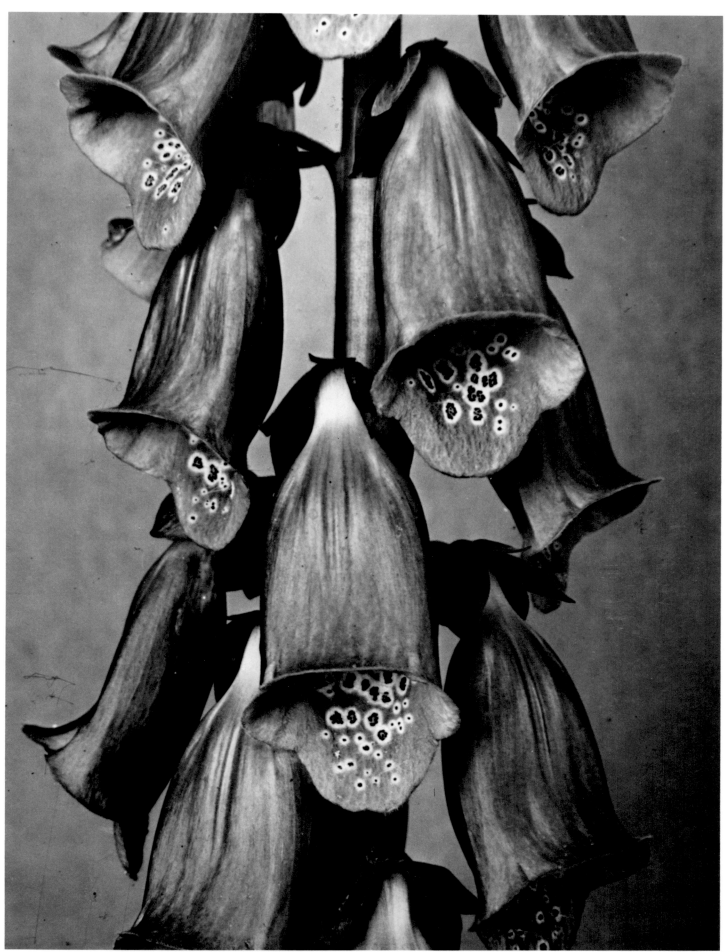

Fingerhut (Foxglove), ca. 1924

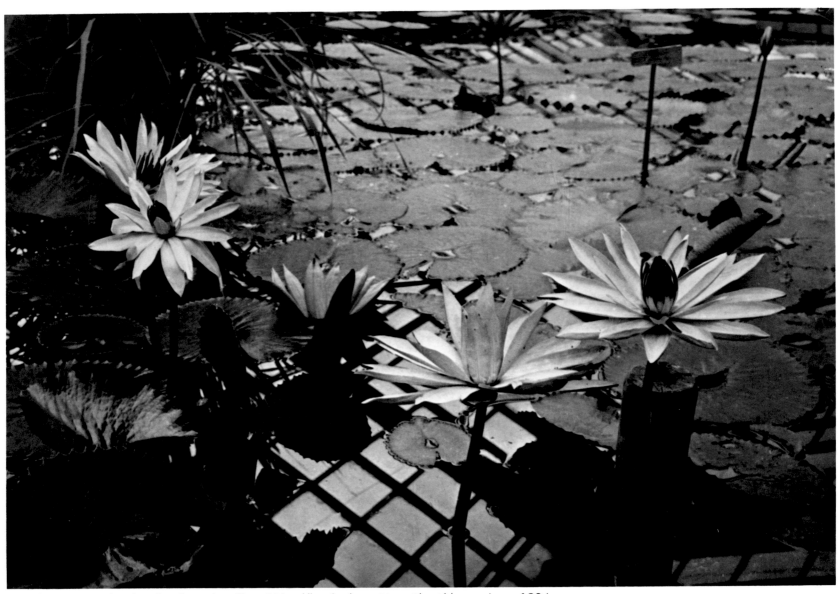

Nymphaea Cotus Ribra/Nachtstellung ohne Bluten (Waterlillies/night position without blossoms), ca. 1924

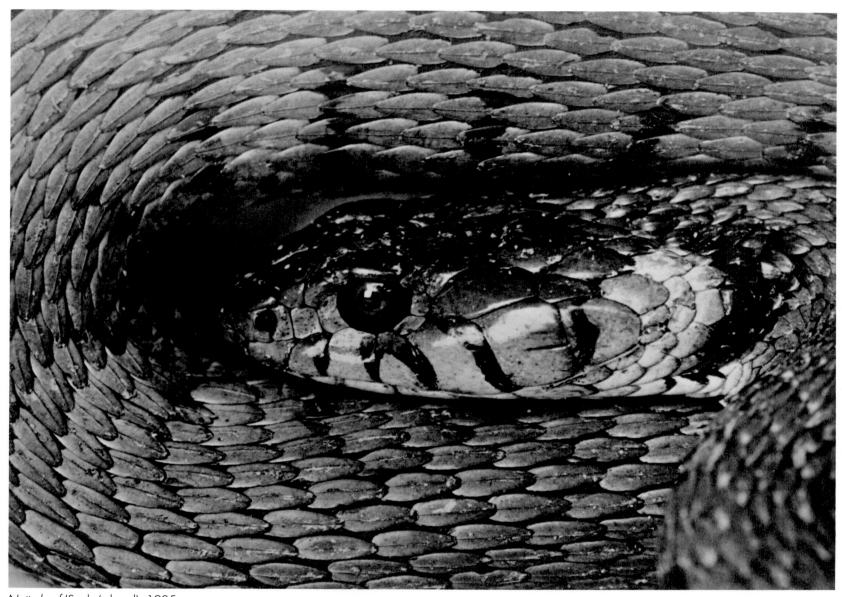

Natterkopf (Snake's head), 1925

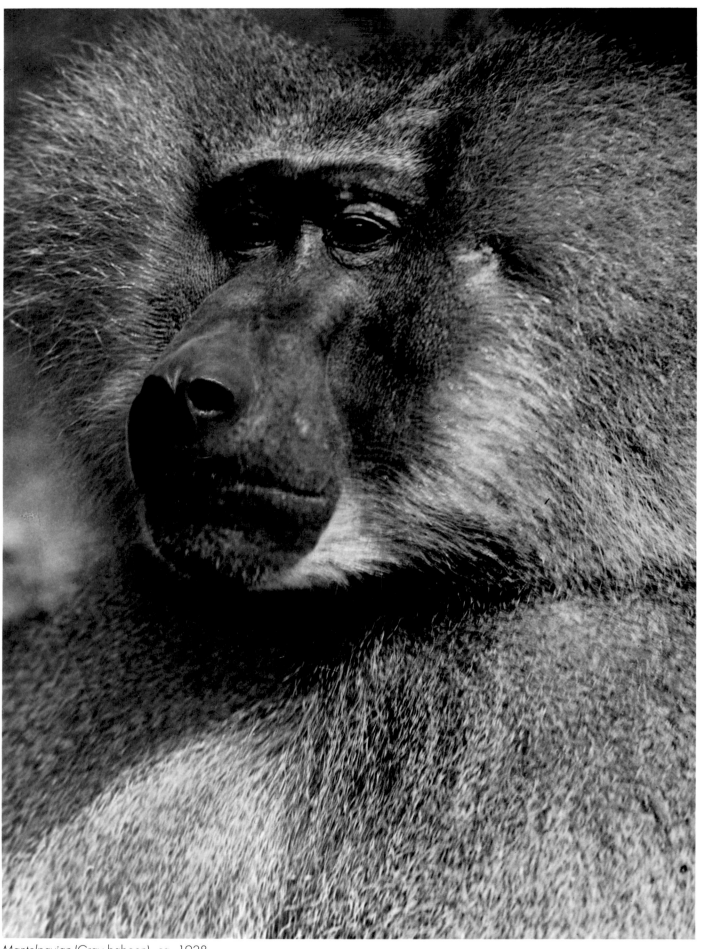

Mantelpavian (Gray baboon), ca. 1928

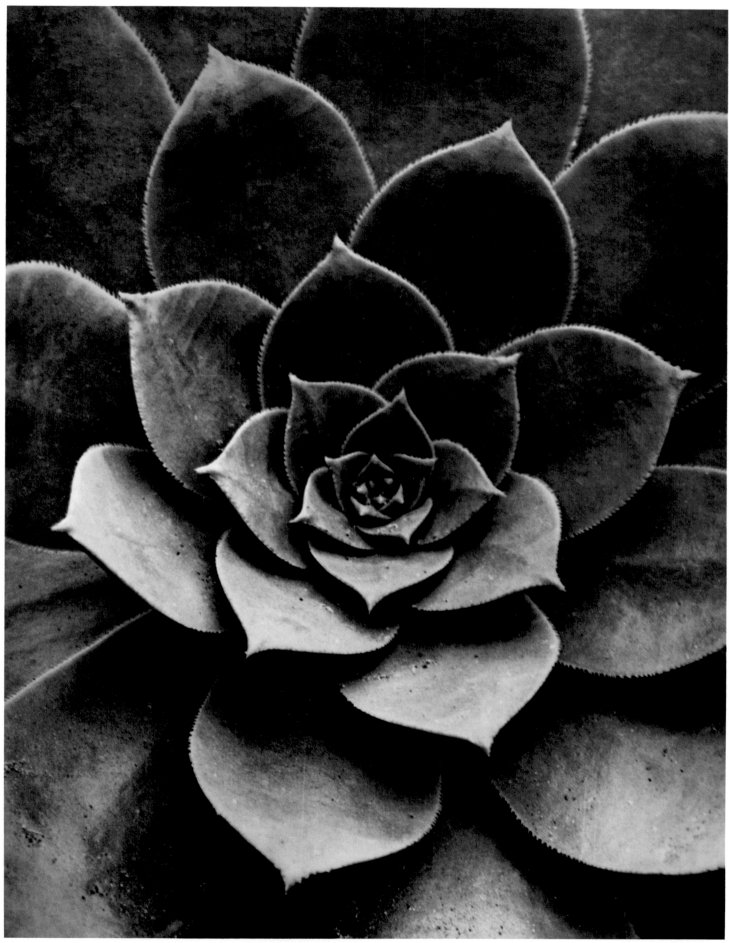

Sempervivum Percarneum, ca. 1928

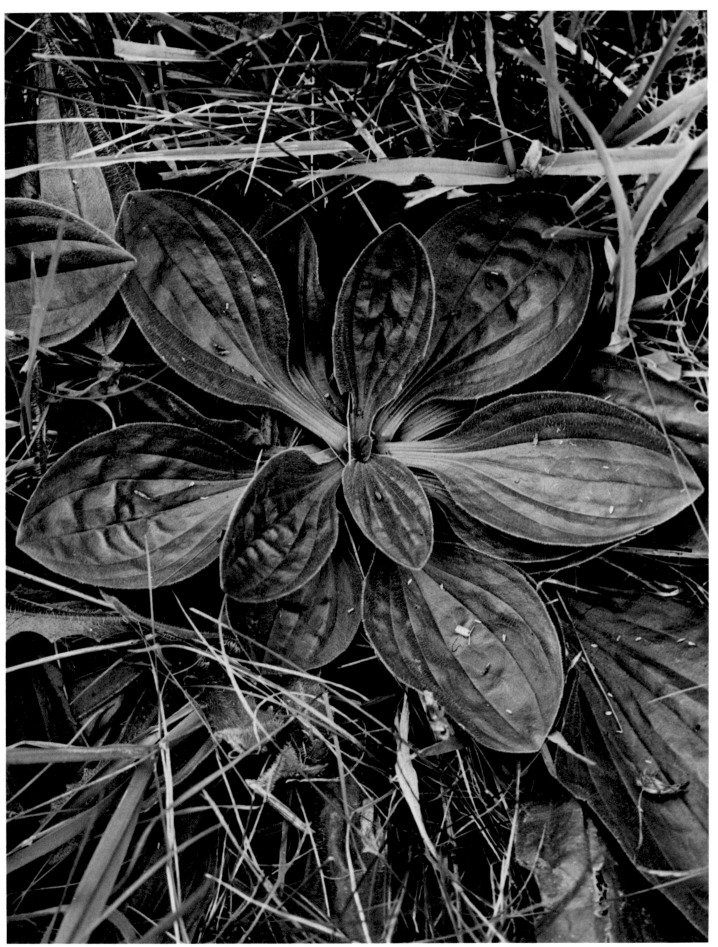

Blattrosette des Breitwegerichs (Leaf rosette of the wide plantain), ca. 1924

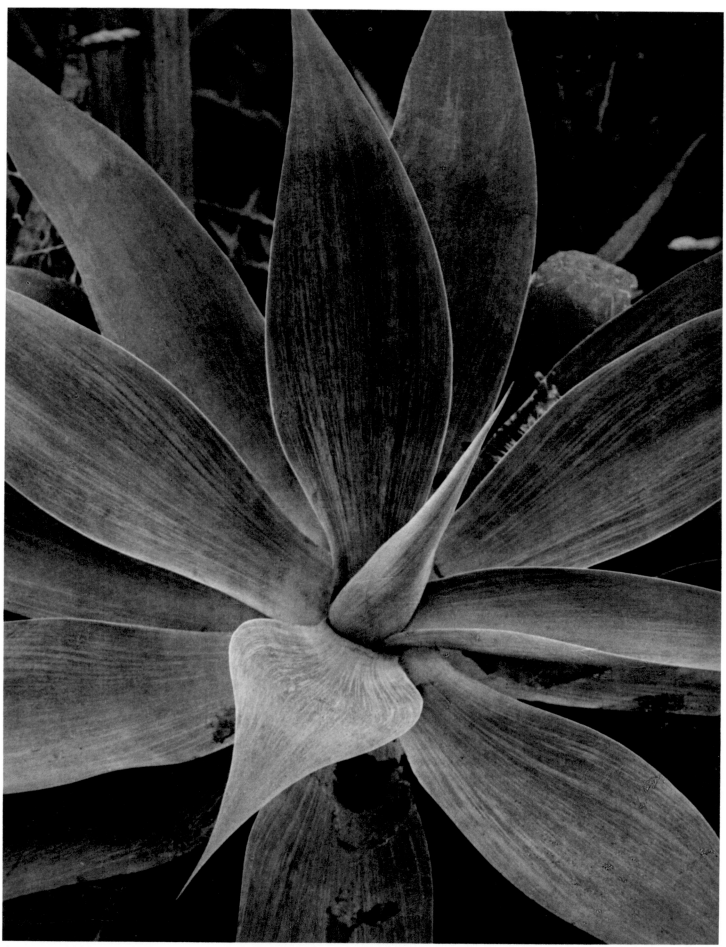

Agave, ca. 1928

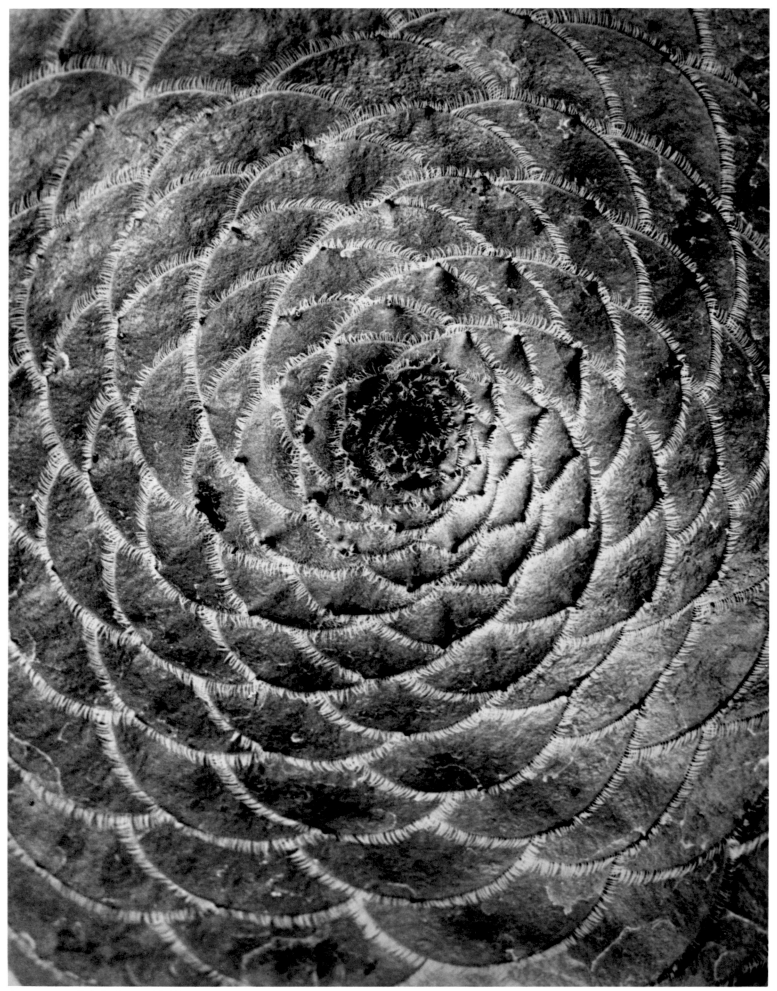

Sempervivum Tabulaeforme, 1922

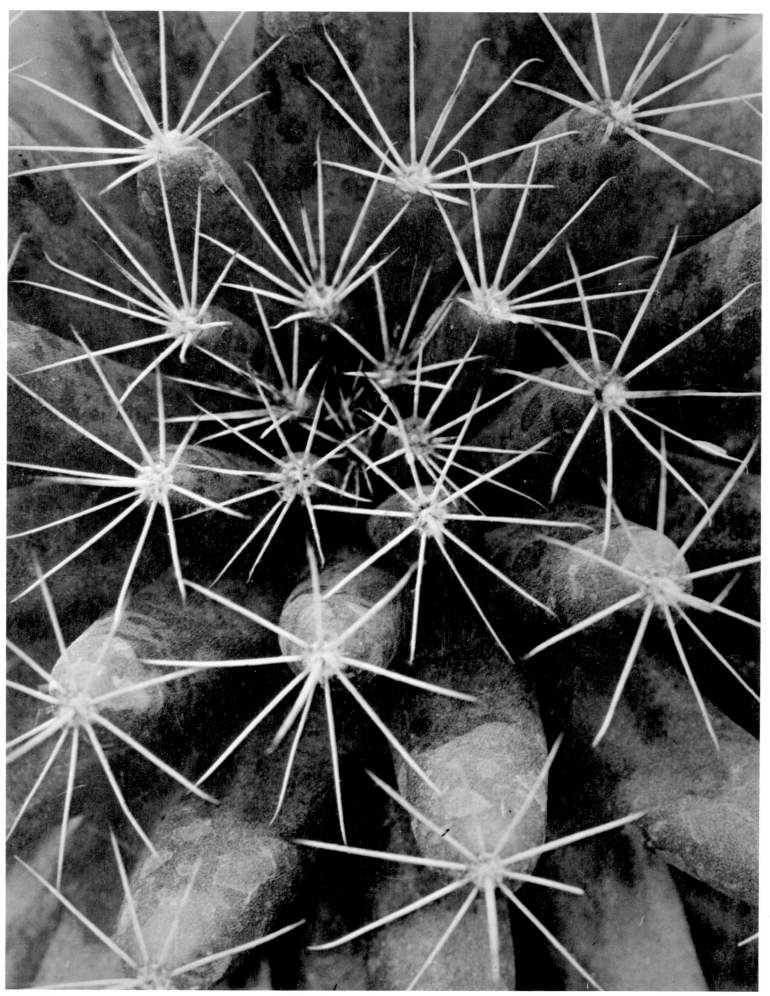

Mamunillaria Cogimanunea, ca. 1928

(continued from page 7)

Heartfield, who made photomontage a dialectical, antiaesthetic "political instrument" with "the revolutionary strength of Dadaism," "testing art for its authenticity," like Dada, by showing that "the tiniest fragment of daily life says more than painting."[17] In painting, Benjamin argued, the "picture frame ruptures time"[18] to create a feeling of mythical unity and integrity, repressing the picture's social meaning. And Renger-Patzsch's photography similarly eternalized and aestheticized the miserable social environment. Where Heartfield made social contradictions ironically transparent, Renger-Patzsch made them seem falsely inevitable:

> In Renger-Patzsch, photography could no longer depict a tenement block or a refuse heap without transfiguring it. It goes without saying that photography is unable to say anything about a power station or a cable factory other than this: what a beautiful world! *A Beautiful World*—that is the title of the well-known picture anthology by Renger-Patzsch, in which we see New Matter-of-Fact photography at its peak. For it has succeeded in transforming even abject poverty, by recording it in a fashionably perfected manner, into an object of enjoyment. For if it is an economic function of photography to restore to mass consumption, by fashionable adaptation, subjects that had earlier withdrawn themselves from it— springtime, famous people, foreign countries—it is one of its political functions to renew from within—that is, fashionably—the world as it is.[19]

For Benjamin, Renger-Patzsch's photography is "a flagrant example of what it means to supply a productive apparatus without changing it. To change it would have meant to overthrow another of the barriers, to transcend another of the antitheses, that fetter the production of intellectuals, in this case the barrier between writing and image. What we require of the photographer is the ability to give his picture the caption that wrenches it from modish commerce and gives it a revolutionary useful value."[20] Not only did Renger-Patzsch's photographic "new matter-of-factness," like literature's "new matter-of-factness," make "the *struggle against poverty* an object of consumption,"[21] its emphasis on the sheer givenness of things denied their social text. The photographs didn't seem to interpret things in the act of mediating them, didn't function critically to expose ordinary appearances as an ideological facade and social symptom. For Benjamin, this constituted a social naiveté, which extended into Renger-Patzsch's attitude to the camera. Benjamin implicitly saw photographs as mechanical constructions, reproducing in their smallest details the camera's own mechanicalness; this is why he thought photographs were inevitably, or properly, a means of disillusion-

ment, rather than a new means of illusion.[22] Renger-Patzsch, on the other hand, seemed to regard the camera "mystically," that is, as an instrument of revelation, a way of piously worshiping things.

Political tunnel vision made it impossible for Benjamin to contextualize Renger-Patzsch's photographs in a way that would do them justice. Like commissars of every ideological stripe, he consigned to intellectual oblivion whatever did not seem revolutionarily fit. Perhaps a more considered, less prejudiced look at this work might have put Benjamin's own revolutionary fervor in question. Perhaps he did not want that closer look, for it might have led him to question whether the social or class identity of a thing supersedes every other identity it has. He might have realized that his "Marxification" of things forced them into as narrow and dogmatic a procrustean bed as he thought Renger-Patzsch's sort of contemplation did, without necessarily affording more insight into their reality (as though there was only one salient reality, one relevant kind of insight).

Benjamin failed Renger-Patzsch's photographs, in a failure of seriousness as well as of attention, of imagination as well as of intellect. It was an astonishing lapse for a thinker of Benjamin's astuteness and powers of observation. Taking the shadow of a book, its readymade title, for its substance, he betrayed his attitude toward anything he could not press-gang into the social cause. Loading the dice against Renger-Patzsch by the comparison with Heartfield, he revealed the limits of his own understanding of photography's formal possibilities. Perhaps Benjamin didn't expect photography to *have* formal possibilities. Perhaps, because Renger-Patzsch gave things a certain aura—could photography really do that?—Benjamin found him regressive. As the Wildes note, Benjamin may have attacked Renger-Patzsch's photographs because of their commercial success,[23] which linked them with fashion and entertainment—as though these distractions were the primary reasons that social revolution had not occurred. If so, Benjamin conveniently forgot that Heartfield's photomontages, which he admired for their revolutionary content, were also successful, no doubt in part because they were fashionably and entertainingly avant-garde. Indeed, their aesthetic liveliness converged with their radical chic to make them "high" fashion and entertainment.

Renger-Patzsch was obsessed with things as such; Benjamin was obsessed with revolution. It is as though Benjamin forgot that photography had something to do with perception. Does Namuth appreciate Renger-Patzsch's photographs as he does simply because he is also a photographer, unexpectedly discovering his connection with a predecessor? Benjamin was a social critic and intellectual, sensitive to photography but want-

ing it to serve a revolutionary and theoretical cause; Namuth is a practicing photographer, as absorbed with art and creativity as Benjamin was with revolution, and convinced that before photography is anything else it is a creative process, a creative response to reality, and that a photographer can make as important work as any artist. Indeed, Renger-Patzsch's photography demonstrated the truth of this. Is the idea that photography is a young medium, whose practitioners are still discovering creative possibilities unique to it, reconcilable with the belief that it is simply one more means of social production that must become an instrument of revolutionary politics, that must be enlisted on the right social side lest it fall into the wrong hands?

Namuth notes that he saw his first Renger-Patzsch photograph, *Kauper, von unten gesehen* (Smokestack, as seen from below), 1928 (page 35), in a "shop window in an ordinary neighborhood" in Essen. That city, Namuth's hometown, is also the place where Renger-Patzsch "spent much of his early life" and lived from 1928 to 1944, "when he lost his home and nearly all his archives in an air raid." For Namuth, *Kauper, von unten gesehen* was "a sobering picture, very black and white, with multiple grays all over." The "giant smokestack" rose into the sky "with phallic grandeur." What would Benjamin think of Namuth's sexual association, which shuns sociopolitical meaning? What would he have thought of Namuth's realization, on seeing the image again, years later, "that it had been with me all my life"? Or of Namuth's assertion that a "railing, balcony-like," had been photographed "in such a way that it had "a light and lacy appearance," making the image a creative triumph, for it "was clearly a new way of celebrating the ugly and the banal"?

For Benjamin, the point is not to celebrate, with whatever aesthetic subtlety, the ugly and the banal, but to expose why there is so much ugliness and banality in the world. No doubt he would have regarded Namuth's phallic metaphor as an arbitrary, subjective (if somewhat predictable) association, and, as such, as a distraction from the smokestack's objective social meaning. Another critic might say that Namuth was empathically identifying with a fellow Essener as a way of finding some reason for being in a city that was no longer home—that but for the grace of God, Namuth, like Renger-Patzsch, might have remained in Essen during the war, and might have lost his archives; and that Namuth's phallic projection, a delusion of masculine grandeur, might be a compensation for a feeling of impotence and vulnerability. For Benjamin, this, too, would be irrelevant, subjective speculation.

Is it Namuth who tells us the truth about Renger-Patzsch, or is it Benjamin, or does each only know part of the truth? Or is the truth polyvalent: are both correct? Both men implicitly

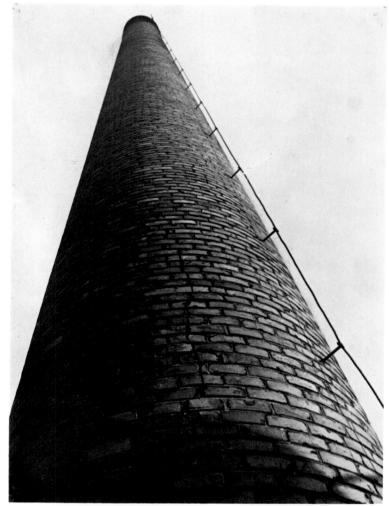

Factory Smokestack, ca. 1925

acknowledge Renger-Patzsch's photographs as uncannily—not just conventionally—true. These images seem to carry photography's vaunted "truth-to-things" to a new level, affording a perceptual epiphany. There is a sense of conviction in Renger-Patzsch's photographs that we do not have in ordinary perception. In fact, for both Benjamin and Namuth, Renger-Patzsch's work is a "peak" of photography—it is Benjamin's word—for the same reason: its remarkable power of transfiguration. For Benjamin, though, this creative power signals complicity in the social status quo, while for Namuth it privileges the works as art. "Renger-Patzsch did not want to be called an artist," Namuth writes; "he felt that photography was not an art, nor a craft, but a category by itself." Yet "his utter simplicity of form and of light versus shadow was perhaps equaled but never surpassed by Edward Weston." (He has been called "the German Weston.") And he achieved a "lyrical *Neue Sachlichkeit*," a "'new objectivity'... of a different order altogether" from what "the Bauhaus had been teaching for a number of years."

THE HIDDEN ORDER
OF DETAILS

Renger-Patzsch's critics invariably categorize his images as part of the *Neue Sachlichkeit* (New Objectivity). (The exception is Richard Müller, who perceptively sees in their "sensuous quality" a certain "visionary" attitude.[24]) The label misses the point: the best of these works are not matter-of-fact descriptions or naive mimetic representations of things, but rather involve an unconscious perceptual identification with them. Renger-Patzsch may have been subliminally aware of this phenomenon, as is suggested by his frequent quotation of Goethe's notion that "the hardest thing to see is what is in front of your eyes."[25]

It is hard to focus on what is in front of one's eyes because that thing is implicitly part of oneself, if only in passing. The sense of immediacy that derives from the focused gaze gives the thing a psychic significance it would otherwise lack, while at the same time making it hard to grasp the depth of that significance. Immanent in the thing is its inner meaning, which, paradoxically, is obscured by its physical immediacy. However, also paradoxically, an aesthetic intensification of such immediacy can disclose inner meaning.

It is an aesthetic feat to see what is in front of our eyes, and one that we rarely attempt. It seems beside the point of our everyday relationship to things to see them aesthetically, let alone ecstatically—it is easier and more practical to deal with them as matter-of-fact signs of themselves. Thus our perception of things can become so habitual that the things seem to be more sign than substance. Actually, seeing them otherwise can be emotionally dangerous.

To mistake a thing as a sign, however, is to be blind to the complexity of its being, and thus be unable to test the reality of that complexity through perception. This also means that one is unaware of the complexity of perception. Renger-Patzsch's images fight this double simplification—of the thing's being, and of the kind of perception that ordinary consciousness carries out to reassure itself. In his best work he enlists the phenomenological pursuit of the self-givenness of the thing[26] in the service of an "aesthetic moment...of 'rapt, intransitive attention,'"[27] a moment involving "perceptual identification" with the thing to the extent of symbiotic merger with it.[28] Both the aesthetic moment, a kind of epiphany of the thing, and the perceptual identification with the thing—an identification that occurs in the aesthetic moment, indeed, that the moment exists to facilitate—have the same refreshing point: the sense that the aestheticized object can in its turn aestheticize or transform the subject, inducing a feeling of being renewed or reborn.[29] The object, then, becomes not just a metaphor for self-transformation and re-creation, but their catalyst.

However unwittingly, Renger-Patzsch made photography a method of phenomenological reduction involving an intuition of the thing in its essential givenness.[30] His images suspend or bracket the existence of the thing in order to articulate its necessity, insisting on its identity as a constant, however manifold our experience of it. Thus Renger-Patzsch privileges photographic perception as a way of establishing the thing's constancy. But the photograph does more for him: it offers an empathic rapport, fusion, and finally complete identification with the thing. His photographs suggest his deep, extraordinary experience of objects by way of their details, which turn the object into an uncanny process, in turn suggesting the uncanniness of one's perceptual relationship with it. This undermines—indeed, overturns—the ordinary, naive reading of these images as matter-of-factly realistic. The phenomenological transformation of the thing is inseparable from the symbiotic transformation of the self, and has the same result: intuition of the self-sustaining process of immanence that the self is, whether as object or subject.

It is, then, to Renger-Patzsch's sense of detail that we must turn—to his intensification of the details that constitute appearances, his way of making the thing seem more profound and uncanny than it does in ordinary perception. If, as Mihaly Csikszentmihalyi argues, attention can be understood as a kind of "psychic energy...under our control, to do with as we please," and if, circularly, "we create ourselves by how we invest this energy,"[31] then Renger-Patzsch invests nearly all the energy of his photographic attention in the details of things, creating an almost autonomous "grain"—a subliminal text of cryptic details that is not entirely readable in terms of the overarching representation, and that encodes an unconscious attitude to the reality it represents. The photographer is the person who can perceive and make visible the hidden order of details, implicitly by acknowledging and mobilizing the hidden order in him- or herself. The externals under control, one is no longer privately anxious. Hence the absence of pathos, social or personal, in Renger-Patzsch's photographs, which many critics have noticed.[32] Renger-Patzsch emphasizes the details of things almost to the point where they disrupt the representation. This is a kind of formalism, in that the details seem ecstatically independent of what they signify, and yet seem to signify something more essential than the representation of which they are a part. Renger-Patzsch does not exaggerate details into distortion; rather, he uses them to undermine any sense of the representation's uniformity. He ingeniously estranges them from the picture as a whole, creating a peculiar effect of disorientation, for all the familiarity of what is pictured. His sense of detail unfreezes the scene, only to leave us caught between the awareness of the object depicted and an intense association with its component parts.

Whether in panoramas like *Gartenkolonie in Bochum* (Garden colony in Bochum), 1929, or in more intimate scenes such as *Winkelstrasse in Essen* (Street corner in Essen), 1939—two among many equally remarkable examples of his Ruhr photographs—Renger-Patzsch shows not simply his power of observation but his ability to give each detail equal weight without denying its integration with the rest of the photograph. So insistent are the details in these works that they form a kind of aesthetic texture apart from the representation—an "inner" composition that is the representation's real point, convincing us of its reality. In *Gartenkolonie in Bochum* the center of gravity is the foreground clothesline, with its sheets and towels, in *Winkelstrasse in Essen* it is the asymmetrically paired street lamp and hydrant, also in the foreground. From these points of departure the details of buildings and terrain spread and accumulate until they threaten to destroy the simple intelligibility of the view as such.

The roof ridges, the garden houses, the factory smokestacks, the church steeple ironically framed by the gas storage tank and barely topping the smokestacks (or is it struggling to reach their height?), all form independent if eccentric strata in *Gartenkolonie in Bochum*, as do the planes of bright snow that edge the roofs, the black metal bars of the fence, the grimy bricks in the wall, and the snow on the ground in *Winkelstrasse in Essen*. So much do these strata have their own formal integrity that they almost destabilize the representation, so that it is only barely seen as completely coherent. Renger-Patzsch's radical attention to the matrix of details—that is, his articulation of them as the roots of the scene—sets it in motion, until it seems simultaneously an expressive process and an invented construction.

This simultaneity is especially evident in Renger-Patzsch's photographs of trees—one of his tree photographs must have suggested Brecht's poem to Namuth—and in those of plants and animals, as in his famous *Natterkopf* (Snake's head), 1927 (page 59). In both its remarkable concreteness and its abstractness, this image is especially telling of the tension between detail and whole that pervades his work. Centered in the image, the snake's head is surrounded by its body. Both are rendered in startling, intimate, relentless detail, underminging any sense of the picture as standard illustration. Indeed, the identity of what we are looking at becomes unclear. If an eye did not mark one side of this flattened ellipse, we would lose the single reference that makes it clear we are looking at a living creature.

The experience of the image as almost an allover abstraction is confirmed by the flattening of the snake's body against the picture plane, making it all the harder to see what we are looking at as a simple matter of fact. Paradoxically, Renger-Patzsch's intense scrutiny of the snake's body renders it inscrutable. Seen up close, rather than at a distance, that body becomes emotionally invasive as well as physically threatening. Renger-Patzsch shows us the evocative power a photograph can acquire simply by violating ordinary proxemics. But the basic point of his close-up seems to be to confront us with a creature utterly alien to us, and at the same time to show its uniqueness. We would find it impossible to imagine the reality of this creature if we weren't brought face-to-face with its unique existence. Renger-Patzsch's strategy of "concrete abstraction," in which details are given a definiteness that shatters ordinary, distanced perception, admirably succeeds. *Natterkopf* is an exemplary case of his generally celebratory approach to nature.

It must be emphasized that the snake's abstractness makes its otherness and difference not only externally real but inwardly real, so that it seems to bespeak the otherness and difference within us. Our eyes consciously moving along the labyrinthine coils that constitute its objective appearance, we unconsciously identify with it. This identification is triggered and reinforced by those coils' hypnotically repetitive scales, which give the snake a peculiar subjective aura. Lured by the strange reality and unreality, concreteness and abstractness, of the snake's body, we immerse ourselves in its mystery. It is as though, in putting this skin before our eyes in all its elementary and elemental detail, Renger-Patzsch were holding up a mirror to our inner selves.

Unexpectedly, Renger-Patzsch's impersonal, meticulously detailed photograph becomes a kind of personal delusion—a hallucinatory projection of an alien, primal part of ourselves, finally recognized and exposed. To the extent that the snake seems "destined" by Renger-Patzsch's "demonstration" of the abstractness of its existence, it bespeaks an aspect of our own destiny.

Wittingly or unwittingly, Renger-Patzsch is determined to "make it new," in Ezra Pound's words, or to afford "the surprise of the new," in those of Baudelaire. He is a modernist artist. The snake becomes new—is reborn in and through perception—in his austere articulation of its details. Pushing this articulation to the point where those details almost become unfathomable, Renger-Patzsch threatens to collapse the intelligibility of the representation. In Christopher Bollas's words, he moves toward "existential as opposed to representational knowing."[33] The object acquires a transcendental necessity, and photographic perception becomes a radical act of knowing, in which the reality of the object, at the same time that it is directly acknowledged, is obliquely brought into question. Showing us the inherent abstractness of the snake's visual appearance (this is not the same thing as rendering it abstractly), Renger-Patzsch makes its existence speculative, as it were—and at the same time all the more certain, through its

presentation as a kind of ideal datum of consciousness. To see these photographs as naively empirical or matter-of-fact is grossly to misread and simplify them.

THE RUHRGEBIET: AN INDUSTRIAL LANDSCAPE

When Renger-Patzsch began to photograph the Ruhr, the area had not yet been discovered as a theme, as Dieter Thoma notes.[34] But Renger-Patzsch's sensitivity led him to recognize a novel world of stark contrasts, sensuous and social. This is a space of black and white, often without mediating gray. It is an inhuman landscape; people have no real home in it, which is why, as Thoma suggests, they appear so infrequently in Renger-Patzsch's photographs. Nonetheless, "the Ruhr region was the most important if not most beautiful part of Germany."[35] Indeed it was the largest industrial complex in Europe.

Renger-Patzsch repeatedly contrasts the natural and the industrial landscapes of the Ruhr, emphasizing the omnipresence of factories and mines. Even his images of rural settlements are disrupted by industrial forms—if only as a narrow band on the horizon. *Landschaft bei Essen* (Landscape near Essen), ca. 1930 (page 26), and *Zeche Carolinenglück in Bochum* (Carolinenglück mine in Bochum), 1935, are cogent examples. Nature appears "naive" here in comparison to technology, though Renger-Patzsch surely wants to show that the Ruhr is not all industrial wasteland. Indeed, it was while he was living in Essen that the city created its botanical garden, and that a concern to preserve green space emerged in the Ruhr in general, to the extent that today 50 to 60 percent of the region is protected nature, as Thoma notes.[36] Nature in fact becomes a signifier of well-being for Renger-Patzsch, for example in *Margarethenhöhe in Essen* (Margaret heights in Essen), 1933, which shows the street where he lived. The middle-class houses on this sedate and quiet road are covered with vines, suggesting vital, happy life within. (The full import of this imagery comes clear when the photograph is compared with those Renger-Patzsch took of the living quarters of miners.)

Renger-Patzsch's many assertions of the contradiction, indeed the incompatibility, between nature and society tend to be dry and understated, making his observations all the sharper. The point is fundamental to his photography, but those who have written about it rarely see that he implicitly uses nature to criticize society. Benjamin was too much the revolutionary optimist to recognize Renger-Patzsch's social pessimism, his articulation of what Jürgen Habermas calls the pathological desolation of modern society, in contrast to the sensuous plenitude of nature. In *Industrielandschaft bei Essen* (Industrial landscape near Essen), 1930 (page 30), for example, nature has been reduced to a small stream, tamed between man-made banks. Its sweeping curve is contrasted with the neatly engineered arc of a bridge in the background—an ironic contrast between nature and the perfection of which man is capable. Elevated, the bridge, a machine for traffic, dominates the picture. All the power and energy of the scene are in it. Nature is impotent in comparison.

Landschaft bei Essen, im Hintergrund die Zeche Rosenblumendelle (Landscape near Essen, in the background the Rosenblumendelle mine), 1928, adds to the contrast of nature and factory an equally ominous contrast for human beings: that between traditional culture, represented by the old timber-beamed peasant's house, isolated by the roadside—it was probably once in the middle of a field—and modernity, repre-

Coal mines at Essen, Schonebeck, 1929

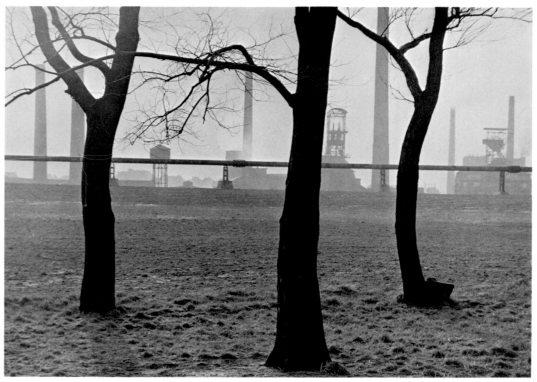

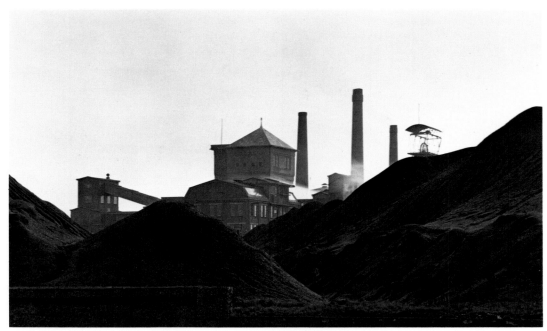

Zeche Rosenblumendelle in Mülheim-Heissen (Rosenblumendelle mine in Mülheim-Heissen), 1929

initially gave many Germans. Hitler would rebuild the country, ending the unemployment and inflation that had almost completely overwhelmed it in the decade after the end of the First World War. But for Renger-Patzsch, the main issue was not Hitler but the restoration of Germany as an industrial power, a restoration symbolized by the new factories. (Renger-Patzsch in fact deplored Nazi anti-Semitism, and was in despair about it.[37]) As Thoma writes, times were not good in the Ruhr valley when Renger-Patzsch made his photographs. After an initial postwar boom there came a bust. "Already by 1926 78 mines were closed, because they were not paying, and 45,000 miners lost their jobs. By 1932 there were 120,000 unemployed."[38]

sented by the industrial complex. A number of photographs of this type must be considered the most directly social of all the artist's works. From 1927 to 1932—and the advent of Hitler—much of Renger-Patzsch's effort was devoted to documenting the desolation of the Ruhr, particularly as reflected in the contrast between the old residential and the new industrial order of architecture. This contrast is the theme of some of his bleakest images.

In photographs of Essen's Victoria Mathias mine made in 1929 and 1931, a modern factory complex dwarfs old buildings, suggesting their inconsequence. They belong to a useless, dead past; the factories signal the brave new world of the present and presumably the future. The difference between—indeed, irreconcilability of—past and present is hammered home in two climactic photographs of the Germania mine in Dortmund-Marten, taken in 1935. These are among the last of the Ruhr images. Here the contrast between old and new is starker and more absolute than ever, and the new's dominance of the old is unmistakable.

In some of his work from the late twenties into the thirties, Renger-Patzsch seems to be idealizing the factories. There may have been a period when he hoped that a rational new industrial and, by implication, social order would replace the tired old irrational order, as is suggested in the comparison of the old and new structures in *Wasserturm und alter Malakow-Turm in Essen Leithe* (Water tower and old Malakow tower in Essen-Leithe), 1929. The plant in *Benzölfabrik Scholven in Gelsenkirchen* (Scholven gas factory in Gelsenkirchen), 1934, has a crisp, new look—perhaps suggesting the hope Hitler

Renger-Patzsch had in fact been more or less consistently interested in the rebuilding of Germany, and especially of its industrial base, as his *Kühlturm im Bau* (Cooling tower under construction), 1927, suggests. He apotheosizes the idea of an enlightened new order in the mathematically clear, streamlined, generally "scientific" structure of the factory complex in his 1927 and 1929 photographs *Zeche Sollverein 12 in Essen* (Customs union 12 mine in Essen). *Zeche Nordstern in Gelsenkirchen* (Northstar mine in Gelsenkirchen), 1928 (page 40), an industrial landscape of 1929, and *Gasometer bei Bochum* (Gas storage tank near Bochum), 1931, offer similar idealizing, "intellectual" close-ups of parts of an industrial complex.

When Renger-Patzsch focuses on the modern factory as a thing in itself rather than as an aspect of a landscape, he typically does not simply substitute the part of the factory photographed for the whole industrial complex in standard metonymic fashion. Making the part fill the image completely, so that it becomes a pictorial whole, he suggests the incomprehensible grandeur of the complex, despite its rationality and orderliness. These photographs seem to illustrate, in however paradoxical a way, what Kant called the mathematical sublime: if the part is overwhelmingly gigantic, the whole must be all the more so. The knowledge that the entire industrial complex is rationally ordered seems unimportant, even meaningless, in the light of our awe at its seeming endlessness. In *Zeche Nordstern in Gelsenkirchen* and the two versions of *Zeche Zollverein 12 in Essen*, perspective is foreshortened

almost to the point of spatial collapse, making the structure even more intimidating and exalted. Indeed, the incidental, miniature, miragelike appearance of the thin sliver of nature in the 1929 *Zeche Zollverein 12 in Essen*, and of the toylike railroad cars of raw material in *Zeche Nordstern in Gelsenkirchen*, makes transparently clear the awesome character of the factory area photographed, and by implication of the complex as a whole.

This awe, however submerged in the ostensibly documentary character and technical finesse of the photographs, suggests an optimism about modernity. Yet the majority of the photographs Renger-Patzsch made before Hitler came to power document the depression and desolation of the Ruhr, and imply that these were a consequence of industrialization. Here, Renger-Patzsch seems to suggest that modernization has had a devastating effect on human beings—indeed, that it is carried out in indifference to them; and, moreover, that it is inevitable. The photographs of the Ruhr as a human wasteland suggest the difficulty of adapting to industrialization. But the photographs glorifying factory architecture show Renger-Patzsch's own adaptation to it.

If, before Hitler's accession, Renger-Patzsch responded to modernity with ambivalence, after Hitler he seemed to celebrate it, apparently uncritically, for example in his numerous photographs of modern buildings, machines, tools, and such mass-produced goods as a bottle of Coca-Cola and a cup of instant coffee—the new, modern drinks, requiring little or no human care. But at second glance these images are more complicated. For one thing, they have to be understood as in part the result of economic necessity. Having resigned his teaching position in 1934, Renger-Patzsch worked for industrial and architectural firms until he left Essen, in 1944, after the bombing raid that destroyed his archives. Thus the photographs he made during this decade are commercial, and reflect the interests of the firms for which he worked.

Renger-Patzsch's own interests showed, however, in his aestheticization of the industrial structures and products he photographed. He did not simply report their modern look; instead, he treated them as he had treated the plants and animals in *Die Welt ist schön*. But where his approach to living beings was celebratory—his perception of them amounting to an ecstatic fusion with them—in his thirties work, aestheticization was an instrument of depression. Whether natural or manmade, his thirties things are presented in a more depersonalized way than his twenties things. Both are equally isolated, but the glossy, cool modernity of the thirties things, such as *Hitzebeständige Laborgläser* (Heat-resistant laboratory glasses), 1936 (page 54), bespeaks indifference rather than identification. Renger-Patzsch rarely came as close to the thir-

ties things as he did to the twenties things. He seems to have been trying to maintain his distance and detachment in modern anonymity, which must have perfectly suited his feeling of not really existing in his own right, as an independent photographer and person. The recognition that came with his commercial commissions reflected the establishment's sense of his usefulness, not its respect for his art. Thus his sense of distance reflected a certain depression.

In a sense, Renger-Patzsch carried the depression of the Ruhr in the late twenties with him into the Nazi thirties, which initially promised liberation from it. There were no doubt good reasons for him to do so, but Renger-Patzsch came to realize, if at first unconsciously, what Hitler meant for Germany: not just resurrection as an industrial power, but the use (and excuse) of industrialism to create a totalitarian society in which difference and uniqueness were suppressed—just as Renger-Patzsch's photographs implied. The Nazis encouraged a totalitarian attitude to things, so to speak, regarding them as indifferent instruments rather than as perceptual ends in themselves. For Renger-Patzsch, this was probably almost as devastating as the fact that under Nazi rule, modern industry and technology were in the service of totalitarian enslavement—a greater betrayal of humanity than the Ruhr depression, which made vulnerable human beings into wage slaves.

Renger-Patzsch's only weapon against this corruption of modernity was photography, which he used to keep alive his sense of the radical differences between things, their existential uniqueness. But he knew his photographs had to become commercial, and, worse yet, had to submit to the totalitarian attitude. His thirties things are no longer subtly and insistently differentiated—no longer really unique, that is, uniquely real. They are still lifes, in all the sinister sense of that term: they are *natures mortes*. Not only are they depersonalized, they lack the material weight and textural density of his twenties things, which burst with life. For the depressed Renger-Patzsch of the thirties, things died. His commercial imagery can be understood as a kind of mourning for his old attitude to them.

Thus Renger-Patzsch standardized his method of presenting objects into a matter of routine craft, a transparently technical strategy. For all their modernity, his thirties things are listless to the point of inertness, especially in comparison to his industrial landscapes of the late twenties. There is no twenties photograph as mechanical and static as the thirties photographs. Generally speaking, in the thirties Renger-Patzsch photographed not the scene of work (or if he did, it was didactically, as an object lesson) but its products, conceived as commodity fetishes. It was only after the Second World War, when he turned away from the industrial landscape and devoted himself to nature, as though seeking a healing refuge

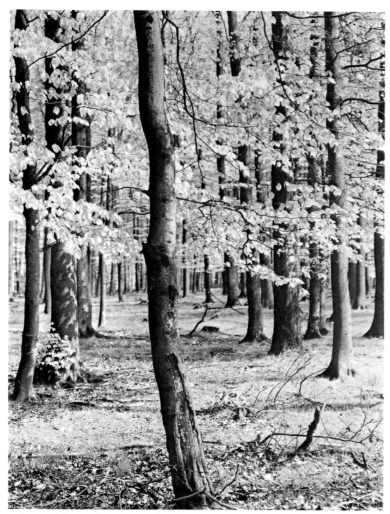

Birkenwald im Frühjahr (Birch forest in spring), ca. 1960

there, that his photographs recovered their power and his things their vital energy.

In these late works, Renger-Patzsch focuses on things and terrain as though to celebrate and participate in the rebirth of life after the death of German society. There is once again a sense of renewal through identification with an organic object. Renger-Patzsch did not quite identify with the commercial products and structures he photographed in the thirties, but now, once again, he let himself become part of his themes, and chose them because they were part of himself. It's true, however, that he no longer came as close to them—established an ecstatic, consummatory relationship with them—as he once

did. Wartime weariness and wariness had infected him forever. He no longer expected, as he wrote in 1960, anything more from "modern mass society."[39]

RETURN TO THE FOREST

During the half decade before 1932, Renger-Patzsch had roamed the streets of the industrial landscape at will, as his numerous photographs of them indicate. He appreciated the simple aesthetics of their curves, and acknowledged them as the arteries through which the lifeblood of the industrial revolution coursed. They symbolized its universal reach—its power to enter every life. *Essen-Bergeborbeck* and *Landstrasse bei Essen* (Provincial street near Essen) (page 31), both 1929, are remarkable examples, as are *Alte Chaussee* (Old highway) and the photographs of straight provincial highways that he took in 1927. The railroad tracks in his 1929 image of a crossing in Essen-Bergeborbeck, his 1930 images of railroad tracks on the edge of Essen, his 1931 photograph of the tracks near Oberhausen (page 33), and his 1934 photograph of the tracks in the mining area near Dortmund indicate that these too he saw as industrial streets, and, even more than ordinary streets, as paths of progress.

After the Second World War, however, Renger-Patzsch no longer traveled these roads and tracks, nor did he walk the more homely streets of the industrial world. He seemed to have left behind whatever vestige of belief in industrial and social progress he had had, as well as society as such, and made his way—escaped?—into the primal forest. In that traditional German place of refuge and recuperation he found no sign of progress, no trace of a street or of anything unsightly—only the opportunity for self-forgetfulness through communion with the elements and the elemental. Compared to the depressing realism of his Ruhr photographs, with their peculiar sense of conscience, the freshness of Renger-Patzsch's photographs of the forest belongs to the world of fantasy. His photographs of trees and stones may be among his most imaginative and lonely and personal, that is, his least realistic. While he lingers lovingly over their details, they represent his return to the paradise where details signify nothing but themselves, and as such lack answerability.

NOTES

1. Albert Renger-Patzsch, unpublished autobiographical manuscript. From the Special Collections of the Getty Center for the History of Art and the Humanities, Santa Monica.

2. Ibid.

3. Ann and Jürgen Wilde, in *Albert Renger-Patzsch: Ruhrgebiet-Landschaften 1927–1935*, Ann and Jürgen Wilde, eds. (Cologne: Dumont, 1982), p. 170.

4. Signature illegible, letter on Reichskunstwart ministry stationery to Renger-Patzsch, 30 June 1927. From the Special Collections of the Getty Center for the History of Art and the Humanities, Santa Monica.

5. Kurt Tucholsky, quoted in Wilde and Wilde, p. 171.

6. In "Versuch einer Einordnung der Fotografie," a lecture he presented on January 27, 1956, at the Albert Ludwig University in Freiburg im Breisgau, Renger-Patzsch acknowledges the greatness of David Octavius Hill's portraits, an exception to the rule that it is hard for photography to truly articulate internal life through external description. It should be noted that E. G. Vierhuff regards Renger-Patzsch's 1927 Halligen portraits, with their heroicizing tendency, as latently fascistic, and believes that they were the reason he was invited to lecture at the Folkwang school in 1933. However, as the Wildes note (p. 173), Renger-Patzsch left the school in 1934 because he could not accept the Nazis' inhibition of artistic freedom.

7. Heinrich Schwartz, quoted in Wilde and Wilde, p. 172. Renger-Patzsch himself repeatedly describes photography as "sphinxlike" in that it is part technical, part aesthetic. Those who push it too far toward the aesthetic, in an attempt to make it purely abstract or "nonobjective," such as László Moholy-Nagy and Man Ray, fail it one way. Those who treat it simply as a craft, such as newspaper photographers, fail it another way, although newspaper photography has its use in showing "the chaotic face of a desacralized society." Photography at its best deals with objects. See "Der geistige Standort der Fotographie," *Westfallenspiegel* 11 (November 1953). In "Gedanken uber Fachfotografie," *Fotoprisma* (June 1951), p. 228, Renger-Patzsch writes that "one can recognize really good photography by the fact that rather than showing itself, it makes the object speak."

8. Ibid., p. 173.

9. Wilde and Wilde, in ibid., p. 173.

10. Ibid.

11. Hans Namuth, "Albert Renger-Patzsch: 'The World is Beautiful,'" *ARTnews* (December 1981):136. All subsequent quotations of Namuth are from this source.

12. Wilde and Wilde, p. 171, describe the production of the book in detail. They also note that the title's "optimism" led to a complete misinterpretation of the book by critics who saw its hundred photographs as a deliberately idealistic attempt to declare the world beautiful at a time when society was particularly ugly. As such, the book was inevitably seen as sinister conservative propaganda, as well as absurdly unrealistic art. Renger-Patzsch's subsequent, somewhat repetitive insistence on the purely materialistic, documentary character of his photographs was undoubtedly an attempt to counteract the bad effect of Kurt Wolff's title. However, in lurching defensively to the other extreme, he unwittingly sold himself short in another way.

I would like to thank the Wildes for the information about Renger-Patzsch's work and life they gave me on a memorable visit to their home near Cologne. All translations from their German in my essay are my own.

13. Renger-Patzsch, quoted in Wilde and Wilde, p. 173. This statement was made in a letter of 11 November 1930 to the art historian Franz Roh, author of the legendary book *foto-auge* (foto-eye).

14. Helmut Gernsheim, letter to Renger-Patzsch, 24 March 1956. From the Special Collections of the Getty Center for the History of Art and the Humanities, Santa Monica.

15. Walter Benjamin, "The Author as Producer," 1934, reprinted in *Reflections* (New York: Harcourt Brace Jovanovich, Harvest/HBJ Books, 1978), p. 229.

16. Ibid.

17. Ibid.

18. Ibid.

19. Ibid., p. 230. Three years earlier, in his "Brief History of Photography" (1931), Benjamin had used the title of Renger-Patzsch's book as a symptom of all that is wrong with photography—and with artistic creativity in general—in capitalist society, contrasting it with the presumably more social-critical photography of August Sander, whose 1929 book *Antlitz der Zeit* (Face of our time) he praised as "more than a picture book: it is a training manual." Benjamin wrote, "The more palpable the crisis of the contemporary social order, the more rigidly its individual moments stand in dead opposition to one another, then all the more has the creative...become a fetish, which owes its life only to change in fashion. Creative photography has surrendered to fashion. 'The world is beautiful'—that is exactly its motto, in which the attitude of a photography that presents every tin can in the universe—but cannot grasp the human context of one—is unmasked. As such, its subject, lost in a dream, is a messenger more of its saleability than of its understanding." Quoted in Wilde and Wilde, pp. 171–72. The Wildes think this statement shows Benjamin's uncertainty about Renger-Patzsch's work, which he probably knew only in a fragmentary way.

Sander, of course, became a hero of the left for being persecuted by the Nazis, but this had more to do with his son's anti-Nazi work than with his photography. See Robert Kramer, *August Sander: Photographs of an Epoch 1904–1959* (New York: Aperture, 1980), p. 30. No doubt Sander's own resistance to the Nazi regime—which sometimes took the form of aiding Jews, but more often was simply an expression of his "irascible nature" (p. 36)—also played a role in his elevation to the role of an antifascist hero. In fact, Sander survived the Nazi period by doing industrial and advertising work (p. 36)—as Renger-Patzsch did. And the two men had the same documentary conception of photography (p. 30). Indeed, Sander's 1936 photograph of the Autobahn bridge near Neanderthal in the Rhineland is adulatory of Nazi achievements in a way that Renger-Patzsch never was, even indirectly. The photograph actually shows a parting of the heavens by light, like the light that illuminates the arrival of Hitler in Leni Riefenstahl's *Triumph of the Will*. And Sander's photographs of Sardinia from 1927 make poverty more an object of enjoyable consumption than any of Renger-Patzsch's sober photographs of miners' homes in the Ruhr. Also, Sander's photographs of nature are more explicitly—mystically—"Germanic" in intention than any Renger-Patzsch made (p. 34). In blindly elevating Sander over Renger-Patzsch, Benjamin revealed the bad though not unfamiliar critical habit of setting up a facile hierarchy of artists working in the same medium.

20. Ibid.

21. Ibid., pp. 231–32.

22. In "The Work of Art in the Age of Mechanical Reproduction," *Photography in Print: Writings from 1816 to the Present*, ed. Vicki Goldberg (New York: Simon and Schuster, Touchstone Books, 1981), Benjamin writes that "in photography, exhibition value begins to displace cult value" (p. 329), and that cult value is the source of the traditional work of art's "uniqueness, that is, its aura" (p. 325). Such displacement is disillusioning, then, and the photograph is emblematic of—embodies—this disillusionment (or is it enlightenment?). Carried to its logical conclusion, Benjamin's argument suggests that the photograph is self-disillusioning, as it were. That is, once we recognize it as a mechanical production, once we realize that all of its details are mechanical, it loses even exhibition value. It becomes simply the anonymous product of a productive apparatus, which can be appropriated for whatever social purpose—revolutionary or fashionable—one wishes.

Benjamin has little understanding of the purpose of exhibiting not only a traditional work of art once it is no longer a cult object, but the photograph that never was one. He fails to recognize that photographs have become cult objects, or, rather, were so from the beginning, not only because they present the "human countenance" (p. 329) but because they extend memory, just as the telescope and microscope extend vision. This is what gives them part of their aura.

23. Wilde and Wilde, p. 172.

24. Richard Müller, in his review of the Wildes' book, *Fotokritik* (January 1982).

25. For example, in "Versuch einer Einordnung der Fotographie." Namuth also uses the quotation to interpret Renger-Patzsch's intentions.

26. "A thing may be *adequately* apprehended in 'self-giving' perception," which involves "original" apprehension of it. But not everything can be originally or adequately apprehended. A tone can be, but melody, which is "spread out in time," cannot be, so that apprehension of it is "in part perception and partly memory." Marvin Farber, *The Aims of Phenomenology: The Motives, Methods, and Impact of Husserl's Thought* (New York: Harper & Row, Harper Torchbooks, 1966), p. 531. At its best, Renger-Patzsch's photography affords a sense of original apprehension of an object, in which its self-givenness and meaning are seamlessly fused one in perception.

27. Christopher Bollas, *The Shadow of the Object: Psychoanalysis of the Unknown Thought* (New York: Columbia University Press, 1987), p. 32.

28. Ibid., p. 14. Bollas's concept of the transformational object informs my discussion throughout.

29. Ibid., p. 16. I am playing on Bollas's sense of the function and effect of the transformational object.

30. As Farber notes (p. 33), this is made possible by "essential intuition, in which an essence is grasped without positing any existence. Essences can be 'seen' just as immediately as tones can be heard." Such givenness precludes "pre-givenness," that is, an existential beginning (p. 34). In the best of Renger-Patzsch's photographs there is a sense of essential intuition and privileged immediacy, that is, a sense of seeing the essence of the thing, with no guarantee that what is seen exists in any ordinary sense. In fact, its enigmatic appearance signals its essentialness. This is not incommensurate with its existence as a transformational object, inasmuch as it functions as one—has the "fundamental" existence such an object has—only in the subject's most essential space, that is, the space in which it knows itself as self-given. Such psychic space is necessarily prior to transitional space, which leads to recognition of the object's existence apart from oneself and one's seeing of it, as Bollas notes.

31. Mihaly Csikszentmihalyi, *Flow: The Psychology of Optimal Experience* (New York: Harper & Row, 1990), p. 33.

32. In "Versuch einer Einordnung der Fotografie" Renger-Patzsch quotes with approval Ernst Jünger's essay on pain, where Jünger asserts that the photograph shows what it shows without "sentimentality"—"precisely, objectively"—hitting its target like a bullet hits a body. Jünger contrasts this with literature, which would describe the object—and the subject who possessed the body that was hit by the bullet—more subjectively. In assuming there is no subjective input to the photograph, Jünger extends the argument that Lessing makes of the *Laocoön*—where sculpture plays the role that photography plays—to reductio ad absurdum. For Lessing, beauty repressed expression, particularly of extreme suffering, while for Jünger photography denies feeling of any kind.

33. Bollas, p. 14.

34. Dieter Thoma, "Im Ruhrgebiet," in Wilde and Wilde, p. 5.

35. Ibid., p. 7.

36. Ibid., p. 11.

37. See Renger-Patzsch, letter to Gernsheim, 27 January 1960. From the Special Collections of the Getty Center for the History of Art and the Humanities, Santa Monica.

38. Thoma, p. 11.

39. Renger-Patzsch, letter to Gernsheim, 27 January 1960.

CHRONOLOGY

22 June 1897 Born in Würzburg, Germany, the youngest of three sons.

1909 First began photographing at the age of twelve as a result of his father's interest in photography.

1911 By age fourteen, the work of Alfred Stieglitz, Edward Steichen, Clarence H. White, and Gertrude Käsebier was well known to him.

1916 Passed the *Kreuzschile*, Dresden certificate in classical subjects.

1916–1918 Served in the German army.

1919–1921 Studied chemistry at the Technische Hochschule, Dresden, but did not complete the requirements.

1921–1924 Appointed head of the Photography Department (with Ernst Fuhrmann) at the Folkwang Archive in Hagen.

1923 Married Agnes von Braunschweig.

1923 Appointed head of Visual Propaganda Department, Central Office for Home Affairs, Berlin.

1924 Birth of first child, Sabine.

1924 Worked as a bookkeeper and salesman in Kronstadt Siebeburgen.

1925–1928 Worked as free-lance documentary and press photographer in Bad Harzburg, Germany.

1925 First book wholly credited to Renger-Patzsch, entitled *Das Chorgestühl von Kappenberg* (The choir stalls of Cappenberg); a small volume of pictures of religious wood carvings.

1925 First exhibition in Harzburg.

1926 Birth of second child, Ernst.

1927 First one-person show, at Behn House, in Lübeck.

1928 Publication of *Die Welt ist schön* (The world is beautiful).

1928–1933 Moved to Essen to do free-lance work. Also had the Folkwang Archives' photographic studio and laboratory at his disposal.

1929 Commissioned by the German Teachers' Congress to create a memorial to the town of Dresden in the form of a photographic volume. The resulting book *Dresden* also includes seven photographs by László Moholy-Nagy.

1933–1934 Appointed as instructor and head of the Department of Pictorial Photography in Folkwangschule, Essen. Unwilling to compromise his ideas or sacrifice his academic freedoms, Renger-Patzsch abruptly ended his teaching activities after only two semesters due to the Nazi takeover of the arts.

1933–1945 Concentrated on his own photography in Essen.

1944 Lost his residence and almost his entire archives during a bombing attack at the Folkwang Museum.

1945–1966 Concentrated on his own photography in Wamel bei Soest, Germany.

1957 Recipient of the David Octavius Hill Medal, Gesellschaft Deutsche Lichtbildner.

1960 Recipient of Culture Prize, Deutsche Gesellschaft für Photographie (DGGPh).

1961 Recipient of Gold Medal, Photographische Gesellschaft, Vienna.

1964–1966 Member, Gesellschaft Deutsche Lichtbilder.

1965 Recipient of State Prize for skilled crafts, Norderhein-Westfalia.

27 September 1966 Died in Wamel bei Soest.

SOURCES: *Contemporary Photographers*. Ed. George Walsh, Colin Naylor, and Michael Held. St. Martin's Press: New York, 1982. Kempe, Fritz. "Albert Renger-Patzsch: 1897–1966 His Life and Personality," *Camera*, April 1967, pp. 52–57.

STUDY RESOURCES FOR THE PHOTOGRAPHS OF ALBERT RENGER-PATZSCH

COMPILED BY VIRGINIA HECKERT AND JOAN GALLANT DOOLEY

THE PHOTOGRAPHS

HOLDINGS OF THE J. PAUL GETTY MUSEUM

Albert Renger-Patzsch is represented by more than two hundred photographs in the collection of the J. Paul Getty Museum. These holdings complement the Museum's significant collection of over 2,600 German photographs, which includes more than 1,200 prints by August Sander and an additional 1,200 by other photographers of the Weimar period. Among those represented are: Ellen Auerbach, Hans Bellmer, Hans Finsler, Erna Lendvai-Dircksen, Werner Mantz, Franz Roh, Else Thalemann, Alfred Otto-Wolfgang Wols, Willy Otto Zielke, plus a substantial gathering of work from the Bauhaus School.

The Renger-Patzsch holding includes twelve photographs from *Die Welt ist schön* (plate numbers from the 1928 edition follow titles in parentheses):

Agave (7); Baboon/*Mantelpavian* (21); Sick Monkeys/*Kränke Affchen* (22); Young Bull/*Junger Stier* (26); Shrimp-fisherwoman/*Krabbenfischerin* (32); Road through a Vineyard/*Weinbergweg* (36); Glass/*Glas* (53); Paint Box/*Farbenkasten* (54); Lübeck (66); Barge with Pile of Sand/*Schute mit Sandhaufen* (88); Flat Irons for Shoe Manufacture/*Bügeleisen für Schuhfabrikation* (93); Heart of an Agave/*Kernstück einer Agave* (99).

In addition, the Museum holds roughly seventy architectural studies, forty landscapes, thirty-five industrial studies (close-ups of machinery and products), twenty botanical studies, and twenty portraits (including ten of animals), and three studies of a potter's hands at work. The collection is particularly strong in Renger-Patzsch's prewar photographs, although some later work is represented. Approximately sixty-five date from his very early years in Hagen and Bad-Harzburg, 1922–1928 (dated by the artist's stamps on the versos of the prints). Also notable are two portraits of Renger-Patzsch made by his daughter Sabine.

The provenance of the bulk of this holding is from three collections acquired in 1984. Ninety-four prints were purchased from Ann and Jürgen Wilde, primarily landscapes, architecture, and industrial subjects in the Ruhr district (84.XM.173.1–.94). Many of the versos of these prints bear the artist's "Wamel" stamp, which he used during the postwar period. Thirty-eight prints were acquired from the Volker Kahmen and Georg Heusch collection, including landscape, architecture, portraits, and industrial and botanical studies, all represented in fairly equal proportions (84.XM.138.1–.38). Most of these prints date from Renger-Patzsch's early years in Bad-Harzburg, 1925–28, and are stamped on the verso with his "Bad-Harzburg" stamp. A group of forty-one prints was acquired from Daniel Wolf (from various sources) including primarily industrial studies from his Bad-Harzburg and Essen years, 1925–1944, and some earlier botanicals and portraits (84.XM.207.1–.40 and 84.XP.208.193).

In 1990 an additional thirty prints were purchased, primarily architectural studies from his Essen period (90.XM.101.1–.29 and 90.XM.102). Among these is a cohesive group of seventeen prints dating from 1928–29 documenting the Women's School of Social Work (Soziale Frauenschule) in Aachen. This group contains a small collection of related ephemeral material including an issue of the journal *Die Form* (15 January 1931) with an article on the Frauenschule illustrated with Renger-Patzsch's photographs.

NORTH AMERICAN COLLECTIONS (HOLDING FIVE OR MORE PHOTOGRAPHS)

The Art Institute of Chicago (11)
California Museum of Photography, University Print Collection, University of California, Riverside (28)
Canadian Centre for Architecture, Montreal (25)
The J. Paul Getty Museum, Malibu (204)
International Center of Photography, New York (5)
International Museum of Photography at George Eastman House, Rochester (19)
Albin O. Kuhn Library and Gallery, University of Maryland, Baltimore (21)
Los Angeles County Museum of Art (10)
Metropolitan Museum of Art, New York (12)
Museum of Fine Arts, Boston (13)
Museum of Modern Art, New York (19)
New Orleans Museum of Art (7)
Harry Ransom Humanities Research Center, University of Texas at Austin (35)
San Francisco Museum of Modern Art (8)
University Art Museum, University of New Mexico, Albuquerque (11)
Worcester Art Museum (10)

EUROPEAN COLLECTIONS (HOLDING FIVE OR MORE PHOTOGRAPHS)

Berlinische Galerie, Berlin (5)
Bibliothèque Nationale, Paris (25)
Deutsche Gesellschaft für Photographie, Cologne (20)
Kunstbibliothek, Berlin (32)
Museum Folkwang, Fotografische Sammlung, Essen (233)
Museum Ludwig, Cologne
 (1070, including ca. 1000 prints and 1500 glass negatives for the spinning machine firm Schubert & Salzer, Ingolstadt, 1955–1966)
Museum für Kunst und Gewerbe, Hamburg (142)
Museum für Verkehr und Technik, Berlin (83)
Kunstbibliothek Berlin (32)
Österreichisches Fotoarchiv im Museum moderner Kunst, Vienna (24)
Schleswig-Holsteinisches Landesmuseum Schloss Gottdorf, Schleswig (46)
Stedelijk Museum, Amsterdam (19)
Technisches Museum, Dresden (33)
Ullstein Bilderdienst, Berlin (41)

ALBERT RENGER-PATZSCH PAPERS AT THE GETTY CENTER FOR THE HISTORY OF ART AND THE HUMANITITES

The Getty Center houses the bulk of Renger-Patzsch's literary estate, an archive that ranges from correspondence, manuscripts destined for publication, and working notes, to albums with press notices of various types. Acquired by the Getty Center in 1986, this archive documents the specifics of the artist's personal and professional life, as well as establishing the intellectual background for his thinking on art and photography. The files of approximately 4,000 pages are catalogued and indexed by correspondent and subject. A detailed summary of the archive is available on the ARLIN electronics data base, which can be found in many public and institutional libraries.

Correspondence

The incoming and outgoing correspondence is divided into two series, prewar (1924–1936) and postwar (1945–1966), and is arranged alphabetically by correspondent. The prewar correspondence is the less complete of the two series but it both represents the diversity of Renger-Patzsch's intellectual concerns during the formative years of his career and reflects his acquaintance with prominent figures in the fields of photography, painting, architecture, and literature. Among his correspondents are Peter Behrens, Ernst Fuhrmann, Hugo Erfurth, Emil Otto Hoppé, El Lissitzky, Thomas Mann, Johannes Mohlzahn (who designed the letterhead for Renger-Patzsch's stationery), Lázsló Moholy-Nagy, Josef Pescí, Jan Thorn-Prikker, and Mary Wigman. Of further interest is correspondence related to the publication of *Die Welt ist schön* issued by the Kurt Wolff Verlag of Munich in 1928.

There is no incoming or outgoing correspondence from the Nazi years, 1936–1945. The fact that not a single sheet dating from this period is to be found in the Getty Center Renger-Patzsch archive raises the question of whether this portion of his papers has survived, and if it has survived, where it is located now.

The postwar correspondence series includes carbon copies of virtually all outgoing documents. Its contents range from perfunctory acknowledgment of orders for prints from existing negatives from the numerous architectural and industrial firms that had commissioned his work over the years to documents that record his private thoughts on art and literature. Short letters of introduction from editors and publishers often request pictures or writing from him. Lengthy exchanges with publishers and printers provide insight into Renger-Patzsch's attention to the details of the editing and production of his own numerous book projects. In the exchanges of letters we witness the unfolding of his plans for exhibitions, publications, and lectures, as well as being privy to his occasional complaints of failing health. Often included are copies of his proposals to promote special projects.

Perhaps most valuable to historians of photography and culture in general are the exchanges that took place over many years, sometimes decades, with professional colleagues with whom Renger-Patzsch also established lasting personal friendships. Among the most notable of these are: correspondence between 1927 and 1964 with the art historian Carl Georg Heise (1890–1979), and between 1955 and 1966 with the photo historian Helmut Gernsheim (b. 1913). Heise was one of the first to purchase and exhibit Renger-Patzsch's photographs as art and he wrote the introduction to *Die Welt ist schön*. The correspondence with Helmut Gernsheim concerns such topics as Gernsheim's numerous exhibition and book projects, his efforts to establish a museum for photography in Germany, and the possibility of uniting Renger-Patzsch's collection of photographs and negatives with his own as a commercial enterprise.

There seem to be gaps in the files of materials removed before they were acquired by the Getty Center in the alphabet around the letters *A–C* and *L–P* in the series of postwar correspondence. Some of these gaps can be reconciled by reference to the papers of individual recipients of Renger-Patzsch's letters, such as Fritz Kempe, formerly of the Landesbildstelle, Hamburg, whose papers are now in the collection of the Department of Photographs of the Museum für Kunst und Gewerbe, Hamburg.

Manuscripts

Particularly relevant to the understanding of Renger-Patzsch's views on photography are approximately thirty drafts for articles and lectures (a number of which were published) that are organized in the archive alphabetically by title or opening sentence. Some of the manuscripts are incomplete, some are annotated, and some are duplicate or edited versions. The titles of the unpublished manuscripts are:

"Als ich der freundlichen Aufforderung Professor Steinerts, zu Ihnen von meiner Auffassung der Photographie zu sprechen, zusagte…"; "Ausweg aus dem Chaos: Einige Gedanken zur heutigen Situation der Photographie" (3 versions); "Autobiographisches kann immer allgemein nur interessieren, wenn es entweder durch den klaren Spiegel eines geläuterten Verstandes…"; "Der Mensch—dem Technischen hörig—zerstört seine eigene Wohnung"; "Die Vergewaltigung der Landschaft zu 'kunst'fotografischen Zwecken ist hier verboten"; "Einiges über Portraitfotografie, über Hände und Händeportraits"; "Ersatzteilaufnahmen"; "Fotografischer Mord"; "Landschaft"; "Photogen"; "Sämtliche Drucktechniken sind eine Erfindung des Spätmittelalters"; "Über Architekturaufnahmen"; "Über bestimmte Dinge wird man sich erst klar, wenn man in Lagen gerät, durch die man gezwungen wird, darüber nachzudenken"; "Über die Grenzen der Photographie: Kann die Photographie den Typus wiedergeben?" (2 versions); "Vortrag München"; "Vortrag Münster. Zu den erstaunlichsten Phaenomenen unserer Zeit zählt die Entwicklung der Photographie"; "Wenig bekannt ist, dass mit fotografischen Mitteln ein restlos ähnliches Porträt ganz selten zu erzielen ist…"; "Wo steht die Fotografie heute?" (slide lecture held on 12 March 1956).

The titles of the published manuscripts, referenced in the Bibliography, are: "Architekt und Fotograf"; "Hochkonjunktur"; "Photographie und Kunst"; "Pflanzenaufnahmen"; "Versuch einer Einordnung der Fotografie" (3 versions); "Vom Sinn der Photographie und der Verantwortlichkeit des Photographen"; "Weltausstellung der Photographie"; "Ziele".

Clipping books

Renger-Patzsch's sense of self and his disciplined approach to record-keeping are reflected in four volumes of clippings from newspapers and journals documenting his reception by the press during the years 1927–1932. These records indicate the breadth and extent of his success during the early years of his career, as well as the interest he took in documenting that success.

Other Documents

The Getty Center also holds miscellaneous personal papers such as birth, death and marriage certificates, diplomas and other official documents; a group of four photographs of Renger-Patzsch by his daughter, Sabine, who assisted her father in the darkroom in later years; and a variety of manuscripts related to various book, film, and poetry projects sent by authors and publishers to Renger-Patzsch for review.

THE ANN AND JÜRGEN WILDE COLLECTION

Mr. and Mrs. Jürgen Wilde are the owners of a large holding of materials pertaining to Renger-Patzsch housed at their residence in Zülpich-Mülheim, near Cologne, and designated by them the Albert Renger-Patzsch Archiv. The contents include negatives, personal papers, correspondence, ephemera, and printed matter. A definitive study of Renger-Patzsch's life and work will require collating and comparing the Getty Center holding with that in Cologne, and until this is possible a reliable biography and the full scope of his work will remain unrealized.

BIBLIOGRAPHY
COMPILED BY VIRGINIA HECKERT

BOOKS ILLUSTRATED BY RENGER-PATZSCH ALONE (ARRANGED CHRONOLOGICALLY)

Orchideen. Die Welt der Pflanze, Band. 1. Berlin: Auriga-Verlag, 1924.

Crassula. Die Welt der Pflanze, Band. 2. Berlin: Auriga-Verlag, 1924.

Das Chorgestühl von Kappenberg. Berlin: Auriga-Verlag, 1925.

Die Halligen. Forward by Johann Johannsen. Berlin: Albertus-Verlag, 1927.

Lübeck. Introduction by Carl Georg Heise. Edited by Ernst Timm. Berlin: Verlag Ernst Wasmuth, 1928.

Die Welt ist schön. Edited and introduced by Carl Georg Heise. Munich: Kurt Wolff Verlag, 1928.

Wegweisung der Technik. Erster Teil, Werkbundbücher Band 1. Text by Rudolf Schwarz. Berlin-Potsdam: Müller and Kiepenheuer Verlag, 1928.

Norddeutsche Backsteindome. Described by Werner Burmeister. Berlin: Deutscher Kunstverlag, 1929.

Das Münster in Essen. Edited by Kurt Wilhelm-Kästner. Essen: Fredebeul & Koenen Verlag, 1929.

Eisen und Stahl. Werkbundbuch. Foreword by Albert Vögler. Berlin: Verlag Hermann Reckendorf, 1930.

Hamburg. Introduction by Fritz Schumacher. Captions by G. Kurt Johannsen. Hamburg: Gebrüder Enoch Verlag, 1930.

Verwaltungsgebäude Siedlungsverband Ruhrkohlenbezirk, Alfred Fischer, Essen. Foreword by Philipp August Rappaporte. Texts by Robert Schmidt and Alfred Fischer. Berlin, Leipzig, and Vienna: Friedrich Ernst Hübsch Verlag, 1930.

Leistungen deutscher Technik. Text by Albert Lange. Leipzig: Seemann-Verlag, 1935.

Sylt — Bild einer Insel. Munich: Verlag F. Bruckmann, 1936.

Kupferhammer Grünthal. Vierhundert Jahre Deutscher Arbeitskultur, 1537–1937. Text by Ernst von Laer. Grünthal Aue-Auerhammer: F. A. Lange Metallwerke (private printing), 1937.

Vom Kraußschmied zur Kraußware. Zum 50 jährigen Bestehen der Kraußwerke. Text by F. E. Krauß. Munich: F. Bruckmann (private printing F. E. Krauß, Schwarzenberg), 1937.

Jenaer Glas für Laboratorien. Jena: Schott & Genossen, 1937.

Deutsche Wasserburgen. Text by Wilhelm Pinder. Königstein im Taunus and Leipzig: Karl Robert Langewiesche Verlag, 1940.

Das silberne Erzgebirge. Foreword by F. E. Krauß. Munich: F. Bruckmann (private printing F. E. Krauß, Schwarzenberg), 1940.

Beständige Welt. Foreword by Helene Henze. Münster in Westf.: Der Quell, Verlag K. H. von Saint-George und Strauf, 1947.

Paderborn. Introduction by Reinhold Schneider. Art historical explanations by Wilhelm Tack. Paderborn: Verlag Ferdinand Schöningh, 1949.

Soest. Text by Adolf Clarenbach. Soest: Verlag Mocker & Jahn, 1950.

Rund um den Möhnesee. Text by Helene Henze. Soest: Westf. Verlagsbuchhandlung Mocker & Jahn, 1951.

Münster. Text by Ernst Hövel. Soest: Westf. Verlagsbuchhandlung Mocker & Jahn, 1952.

Schloß Cappenberg. Text by Erich Botzenhart. Soest: Westf. Verlagsbuchhandlung Mocker & Jahn, 1953.

Lob des Rheingaus. Foreword by Ludwig Curtius. Ingelheim am Rhein: C. H. Boehringer Sohn (private printing), 1953.

Höxter und Corvey. Text by Ludwig Rohling. Soest: Verlag Mocker & Jahn, 1954.

Villa Hügel. Text by Gert von Klaas. Essen: Firma Krupp AG, 1954.

Soest in seinen Denkmälern. Text by Hubertus Schwartz. Soest: Verlag Mocker & Jahn, 1957.

Bilder aus der Landschaft zwischen Ruhr und Möhne. Introduction by Helene Henze. Belecke (Möhne): Siepmann-Werke AG (private printing), 1957.

Bauten zwischen Ruhr und Möhne. Introduction by Hugo Kükelhaus. Belecke (Möhne): Siepmann-Werke AG (private printing), 1959.

Hohenstaufenburgen in Süditalien. Text and illustrations by Hanno Hahn. Munich: Verlag F. Bruckmann (private printing C. H. Boehringer Sohn, Ingelheim am Rhein), 1961.

Bäume. Essay by Ernst Jünger. Dendrological explanations by Wolfgang Haber. Ingelheim am Rhein: C. H. Boehringer Sohn (private printing), 1962.

Soest. Alte Stadt in unserer Zeit. Mittelalter und Gegenwart. Text by Hubertus Schwartz. Soest: Verlag Mocker & Jahn, 1963.

Im Wald. Introduction by Wolfgang Haber. Zweckverband Naturpark Arnsberger Wald. Wamel-Möhnesee: Druckwerkstatt Hermann Kätelhön, 1965.

Gestein. Introduction and captions by Max Richter. Essay by Ernst Jünger. Ingelheim am Rhein: C. H. Boehringer Sohn (private printing), 1966.

PUBLISHED WRITINGS BY RENGER-PATZSCH

"Pflanzenaufnahmen." *Deutscher Camera-Almanach* (Berlin) 14 (1923): 49–53.

"Das Photographieren von Blüten." *Deutscher Camera-Almanach* (Berlin) 15 (1924): 104–112

"Photographische Studien im Pflanzenreich." *Deutscher Camera-Almanach* (Berlin) 17 (1926): 137–141.

"Pflanzenaufnahmen im Winter," *Camera* (Lucerne) 5, no. 7 (Jan. 1927): 186–187.

"Photographie und Kunst." *Photographische Korrespondenz* (Vienna) 63, no. 3 (March 1927): 80–82. (Reprinted in English as "Photography and Art" in David Mellor, ed. *Germany: The New Photography, 1927–1933.* London: Arts Council of Great Britain, 1978, and in Christopher Phillips, ed. *Photography in the Modern Era: European Documents and Critical Writing.* New York: Metropolitan Museum of Art and Aperture, 1989).

"Ziele." *Das Deutsche Lichtbild* (Berlin) 1 (1927): xviii. (Reprinted in English as "Aims" in Phillips, *Photography in the Modern Era*).

"Die Freude am Gegenstand." *Das Kunstblatt* (Berlin) 12, no. 1 (January 1928): 19–22. (Reprinted in English as "Joy Before the Object" in Phillips, *Photography in The Modern Era*).

"hochkonjunktur." *bauhaus* (Dessau) 3, no. 4 (Oct–Dec. 1929): 20. (Reprinted in English as "Boom Times" in Phillips, *Photography in the Modern Era*).

"'Halt mal still!' — Über Amateur-Photographie." (With Martin Munkacsi.) *Uhu* (Berlin) 6, no. 10 (1929): 19–26.

"A. Renger Patzsch." *Meister der Kamera erzählen wie sie wurden und wie sie arbeiten*, ed. Wilhelm Schöppe. Halle-Saale: Verlag von Wilhelm Knapp (1937): 49–55.

"Versuch einer Einordnung der Fotografie." Lecture held on 27 January 1956 at Albert-Ludwigs-Universität, Freiburg, Breisgau. Essen: Folkwang Schule für Gestaltung, Schrift 6, October 1958. (Reprinted in English as "An Essay Toward the Classification of Photography" in: *Untitled 12* [Carmel, Calif.: Friends of Photography, 1977]).

"Architekt und Fotograf." *Foto Prisma* (Düsseldorf) 11, no. 10 (October 1960): 548–551 and no. 11 (November 1960): 618–619.

"Versuch einer Einordnung der Photographie." Speech given on 30 September 1960 at the conferment of the Kulturpreis of the Deutsche Gesellschaft für Photographie in Gürzenich zu Köln. Cologne: Deutsche Gesellschaft für Photographie, Heft 4; Darmstadt: Verlag Dr. Othmar Helwich, December 1960.

"Weltausstellung der Photographie." *Foto Prisma* (Düsseldorf) 16, no. 1 (January 1965): 18–19.

"Vom Sinn der Photographie und der Verantwortlichkeit des Photographen." Werkstattforum 1. Arnsberg und Dortmund: Arbeitsgemeinschaft Gestaltendes Handwerk, March 1965.

"Ein Vortrag, der nicht gehalten wurde." *Foto Prisma* (Düsseldorf) 17, no. 10 (October 1966): 535–538.

BOOKS AND ARTICLES ON RENGER-PATZSCH

Der Fotograf Renger-Patzsch. Werkstattportrait 10. Dortmund: Handel, Handwerk und Gewerbe, 1962.

Goldschmidt, W. "Albert Renger-Patzsch und die moderne Photographie." Fotospiegel section of the *Berliner Tageblatt*, 14 June 1928.

Heise, Carl Georg. *Albert Renger-Patzsch der Photograph.* Werkstattbericht des Kunstdienstes 23. Berlin: Ulrich Riemerschmidt Verlag, 1942.

———. "Neue Möglichkeiten photographischer Bildkunst." *Kunst und Künstler* (Berlin) 26, no. 5 (1 February 1928): 182–188.

Kállai, Ernö. Review of *Die Welt ist schön. bauhaus* (Dessau) 3, no. 2, (April–June 1929): 27.

Kállai, Ernst. "Bildhafte Photographie." *Das Neue Frankfurt* 2, no. 3 (March 1928): 42–29.

Kempe, Fritz and Carl Georg Heise. Albert Renger-Patzsch issue. *Camera* (Lucerne) 57, no.8 (August 1978).

Lotz, Wilhelm. "Fotografie und Objekt. Zu den Fotos von Renger-Patzsch." *Die Form* (Berlin) 4, no. 7 (1 April 1929): 162–167.

Mann, Thomas. Review of *Die Welt ist schön.* Berliner Illustrirte Zeitung, 23 (December 1928): 2,261.

Namuth, Hans. "Albert Renger-Patzsch:'The World is Beautiful!'" *ARTnews* 80, no. 10 (December 1981): 136–137.

Newhall, Beaumont. "Albert Renger-Patzsch." *Image* (Rochester, New York) 8, no.3 (September 1959): 138–142.

Pfingsten, Claus. *Aspekte zum fotografischen Werk Albert Renger-Patzschs.* (Dissertation for Friedrich Wilhelm University, Bonn, 1991.) Witterschlick/Bonn: M. Wehle, 1992.

Riezler, Walter. Reviews of *Die Welt ist schön* and *Lübeck. Die Form* (Berlin) 4, no.1 (1 January 1929): 24.

Schleswig-Holsteinisches Landesmuseum, Schloß Gottort, Schleswig. "'...Titel muss noch gefunden werden...': Eine unveröffentlichte Publikation mit Photographien von Albert Renger-Patzsch." *150 Jahre Photographie aus der Sammlung des Schleswig-Holsteinischen Landesmuseums Schloß Gottorf, Schleswig.* Edited by Heinz Spielman. Neumünster: Karl Wachholtz Verlag, 1989: 43–47.

Schwarz, Heinrich. Reviews of *Die Welt ist schön* and *Lübeck. Photographische Korrespondenz* (Vienna) 65, no.5 (May 1929): 156–157.

Sieker, Hugo. "Absolute Realistik. Zu Photographien von Albert Renger-Patzsch." *Der Kreis: Zeitschrift für Künstlerische Kultur* (Hamburg) 5, no.3 (March 1928): 144–148.

Stokoe, Brian. "Renger-Patzsch: New Realist Photographer." *Germany, The New Photography 1927–33*, ed. David Mellor. London: Arts Council of Great Britain, 1978: 95–99.

Wilde, Ann and Jürgen, ed. *Albert Renger-Patzsch, Ruhrgebiet Landschaften 1927–1935.* Texts by Dieter Thoma and Ann and Jürgen Wilde. Cologne: DuMont Buchverlag, 1982.

PUBLICATIONS ACCOMPANYING RENGER-PATZSCH EXHIBITIONS

Bahnhof Rolandseck, near Bonn. *Albert Renger-Patzsch.* Text by Volker Kahmen. Bonn: Edition Bahnhof Rolandseck, 1979.

Friends of Photography, Carmel. Albert Renger-Patzsch exhibition published with text by James Enyeart as special issue of *Untitled 12*: 1977.

Rheinisches Landesmuseum, Bonn. *Industrielandschaft, Industriearchitekur, Industrieprodukt. Fotografien 1925–1960 von Albert Renger-Patzsch.* Edited by Klaus Honnef. Bonn: 1977.

Ruhrland-und Heimatmuseum, Essen. *Albert Renger-Patzsch, Der Fotograf der Dinge.* Text by Fritz Kempe. Essen: 1966.

Sauerlandmuseum, Arnsberg. *Albert Renger-Patzsch Gedächtnisausstellung.* Text by Sabine Renger-Patzsch. Arnsberg: 1967.

Galerie Schurmann und Kicken, Cologne. *Albert Renger-Patzsch, 100 Photographs - Photographien - Photographies 1928.* Texts by Fritz Kempe and Carl Georg Heise. Cologne/Boston: Schürmann and Kicken Books; Paris: Créatis, 1979.

Städtische Galerie Haus Seel, Siegen. *Albert Renger-Patzsch.* Text by Bernd Lohse. Siegen: 1977.

MORE GENERAL PUBLICATIONS WITH REFERENCES TO RENGER-PATZSCH

Haus, Andreas. "Dokumentarismus, Neue Sachlichkeit und Neues Sehen — Zur Entwicklung des Mediums Fotografie in den USA und Europa." *Amerika Studien* (Stuttgart) 26, no.3 (1981): 315–339.

Hayward Gallery, London. *Neue Sachlichkeit and German Realism of the Twenties*, Edited by Wieland Schmied. "Photography and the Neue Sachlichkeit Movement." Essay by Ute Eskildsen. London: Art Council of Great Britain, 1978.

Molderings, Herbert. *Fotografie in der Weimar Republik.* Stationen der Fotografie 2. Berlin: Verlag Dirk Nishen, 1988.

———. "Überlegungen zur Fotografie der Neuen Sachlichkeit und des Bauhauses." *Beiträge zur Geschichte und Ästhetik der Fotografie*, ed. Keller, Molderings, and Ranke. Lahn Gießen: Anabas-Verlag, 1977.

Sachsse, Rolf. *Photographie als Medium der Architektur-interpretation.* Munich: K. G. Saur, 1984.

San Francisco Museum of Modern Art. *Avant-Garde Photography in Germany 1919–1939.* Text by Van Deren Coke. San Fransisco: 1980.

Vierhuff, Hans Gotthard. *Die Neue Sachlichkeit: Malerei und Fotografie.* Cologne: DuMont Buchverlag, 1980.

Worcester Art Museum. *Photographers of the Weimar Republic.* Text by Stephen B. Jareckie. Worcester: 1986.

Library of Congress Catalog Card Number: 93-1906
Paperback ISBN: 0–89381–559–4
Hardcover ISBN: 0–89236–273–1

TEXT CREDITS: Page 28: letter to Helmut Gernsheim, 27 March 1956. From the Special Collections of the Getty Center for the History of Art and the Humanities, Santa Monica. Page 42: from a lecture delivered on 27 January 1956 at the Albert-Ludwigs-University in Freiburg, Breisgau. A translated version is reprinted in: Enyeart, James; Cramer, Anne I., trans. "Albert Renger-Patzsch: An Essay Toward the Classification of Photography." *Untitled* 12. Carmel, California: Friends of Photography, 1977: 21. Page 56: unpublished autobiographical essay. From the Special Collections of the Getty Center for the History of Art and the Humanities, Santa Monica.

Book design by Wendy Byrne. Printed and bound by Everbest Printing Co., Ltd., Hong Kong. Duotone separations by Robert Hennessey

The staff at Aperture for *Albert Renger-Patzsch: Joy Before the Object* is: Michael E. Hoffman, Executive Director; Michael Sand, Editor; David Frankel, Essay Editor; Stevan Baron, Production Director; Sandra Greve, Production Associate; Maryalice Quinn, Editorial Work Scholar

At the J. Paul Getty Museum:
Christopher Hudson, Publisher; Charles Passela, Head of Photo Services; Ellen Rosenbery, Photographer; Rebecca Branham, Photo Technician; Leslie Rollins, Publishing Assistant; Amy Armstrong, Joan Dooley, and Louise Stover, Photo Coordinators

Published by Aperture, 20 East 23rd Street, New York, NY 10010, in association with The J. Paul Getty Museum, 17985 Pacific Coast Highway, Malibu, California 90265–5799.

Aperture Foundation publishes a periodical, books, and portfolios of fine photography to communicate with serious photographers and creative people everywhere. A complete catalog is available upon request.
Address: 20 East 23rd Street, New York, NY 10010.

First edition
10 9 8 7 6 5 4 3 2 1